# POINT AND LINE TO PLANE

# POINT AND LINE TO PLANE

**WASSILY KANDINSKY**

**Dover Publications, Inc., New York**

This Dover edition, first published in 1979, is an unabridged republication of the work as published by the Solomon R. Guggenheim Foundation for the Museum of Non-Objective Painting, New York City, in 1947, in a translation by Howard Dearstyne and Hilla Rebay, edited and prefaced by Hilla Rebay. The work was originally published in 1926 as *Punkt und Linie zu Fläche,* the ninth in a series of fourteen Bauhaus books edited by Walter Gropius and L. Moholy-Nagy.

*International Standard Book Number:*
*0-486-23808-3*
*Library of Congress Catalog Card Number:*
*79-50616*

Manufactured in the United States of America
Dover Publications, Inc.
180 Varick Street
New York, N.Y. 10014

# CONTENTS

# ★PREFACE
## BY HILLA REBAY

Wassily Kandinsky was born in Moscow, December 5, 1866. As a child, he loved to paint. The effects of colours on him were deeply felt. The beauty of the sunset over the cupolas of Moscow and the intensity of colour in peasant art, contrasting with the grey vastness of his native country, enlightened his vision. After terminating his law studies at the age of thirty, he was offered a professorship. In refusing it, at this turning point of his life, he made the decision to abandon a safe career and to leave for Munich to study painting. He later recalled this decision as "putting a final period to long studies of preceding years."

After two years of painting in Munich, he was admitted to the Royal Academy where he studied under Franz von Stuck. This instruction, however, did not satisfy him and in 1902 he opened his own art school, which closed two years later when he undertook a four-year series of travels to France, Italy, Tunisia, Belgium, and Holland. Upon his return to Munich, one evening there occurred at dusk the magical incident of his seeing merely the form and tone values in one of his paintings. While not recognizing its subject, he was not only struck by its increased beauty but also by the superfluity of the object in painting, in order to feel its spell. It took him fully two years to crystallize this miraculous discovery. Nevertheless, he still used objective inspiration in the paintings of this period, but only as a structural element, while the organization of form and colour values, used for the sake of composition, already dominated these abstractions.

*This article on Kandinsky by Hilla Rebay, Director of the Museum of Non-Objective Painting, New York City, was originally published in Pittsburgh in the May 1946 issue of the "Carnegie Magazine" under the title of "Pioneer in Non-Objective Painting."

In 1910, Kandinsky wrote his famous book "On the Spiritual in Art," a theoretical treatise, in which he established the philosophical basis of non-objective painting. The following year he finished and exhibited his first entirely non-objective canvases, which attracted world-wide attention and excited controversies of tremendous import. Between 1914 and 1921 Kandinsky lived in Russia where he acted in several official artistic capacities. In 1919 he became the director of the Museum of Pictorial Culture in Moscow and, as such, founded the Institute of Artistic Culture for which he wrote the recently published Culture Plan. In 1920, he was named professor of art at the University of Moscow. In 1920, also in Moscow, he created the Academy of Artistic Science, of which he became vice-president.

Later that year, Kandinsky returned to Berlin where, at the Wallerstein Gallery, he exhibited his first open-spaced canvases, in which one sees his turning from lyrical organizations of effervescent colour expressions to a more dramatic clarification of definite form and space precision. With infinite care he studied the dimension of open-space in contrast to colour value and form extension, as well as line direction and the intensity of the point. After 1923 he perfected, with scientific precision, his marvelous presentation of colour technique. He also taught at the well-known Bauhaus, first established in Weimar, later in Dessau, until 1933, when prejudiced authorities ordered its closing. Kandinsky then left for Berlin, but finally, the next year, settled in Paris, where he continued his work until his death, December 13, 1944.

As his last paintings prove, with intense concentration, Kandinsky increasingly refined the precision of balance in the given space of the painting, as the innermost powerful essence of its rhythmic tension. Like every creative painter of our day, he ceased to be satisfied with representation, however artistic, but felt more and more the desire to express his inner life in a cosmic organization. He was, however, the first to proclaim this principle; and when he realized that the musician's incorporeal freedom from earthly inspiration for his art was also the privilege of the painter, he became one of the most violently attacked pioneers. He courageously maintained this conviction, in spite of the all-powerful objective tradition

and mass belief. With his God-given freedom in the artistic, esthetic creation of rhythm, he invented the first painting for painting's sake, and not for the sake of informative make-believe, as had been the ideal of the past. He found that a non-objective painting's rhythmic life, expressing creative invention, can be profound if done by a visionary master. It can also have a strong ordering influence on the observer. This, he found, was denied to representative painting, through its imitative, lifeless limitation. Yet this is equally denied to those schematic, mediocre, condensed patterns by most so-called abstract painters, whose decorations are as far removed from being art as the organ-grinder is from musicianship, or as the scale is from the sonata.

The rhythmic law of constructive counterpoint, contained in a creative masterpiece, sets into motion life itself, through a rhythm displayed between harmonies and the contrasts of colour and form, with which the given space is beautified. In order to clarify, for the serious student of painting, the existing counterpoint in the law of correlation, Kandinsky, through intense concentration on these esthetic problems, undertook profound studies, outlined by him in his treatises, as well as in his culture programs. He wrote extensively about the theoretical and technical elements of this art. These writings offer valuable tools to those who are endowed and eager to express their creative urge. At the same time, such knowledge of counterpoint and technical elements is not at all needed by the layman in order to enjoy this art. Without professional knowledge, all he is expected to do is either to like or dislike the painting, as he would a melody or a flower, which, like all other God-given creations, are equally beyond understanding and which, like art, are simply there to be enjoyed.

Because the non-objective painter reacts intuitively to a superior influence and realization of the universal law, thus enabling him to give his message, this sensitive and prophetic artist of our day has refined his senses to receivership of those invisible, spiritual forces which he intuitively expresses. He then derives with subtle sensibility his visionary inspiration from the spiritual domain which is indestructible and his very own, in the same degree in which he has developed his faculty to receive. Thereafter, his creations develop with a wealth of variation those visions of beauty, which,

controlled by laws of counterpoint, make his artistic message as endlessly alive and original as nature itself.

The artistic expression of our day no longer responds to materialistic objectives; it has advanced to become spiritually creative. No longer must the painter display a lemon to paint the beauty of an intense yellow; or search the sky to contrast it with a lovely blue; nor must he anywhere at all hunt for earthly motives before he is permitted to paint. At will, he can now organize forms and colours into the virgin-white, esthetic purity of a given space, which is his canvas; so as to enrich its beauty without disturbing its loveliness, he is now free to follow a higher evolution beyond the pretense of make-believe. Unknown to some painters who miss their epoch and are still shackled by the caveman's out-dated urge for reproduction, the freedom of art has become infinite, through the painter's vision of new possibilities and esthetic expressions which are spiritually conceived and of superior value. The eyes of the painter have been liberated to vision, freed from the bonds of imitation and the pretense of a perspective make-believe, of a faked third dimension, to a visionary reality. The non-objective artist is a practical educator, the bearer of joy and a creator who deals with eternity. His painting gradually elevates the onlooker, through pleasurable realization of esthetic refinement, to harmony containing order, which proves satisfying to the soul's need for perfect peace.

The prophetic, immaterialistic ideal of the modern painter proclaims the coming era of spirituality. His reaching into the absolute emphasized the subconscious desire of all men to such advance. The increase in material ease of life, which man has accomplished by harnessing invisible forces of electrical waves, rays, or atoms, has freed him now and has given him time with which to direct his aims, to increase his cultural and esthetic expression, and to contact the eternal realities of permanence, so close to all and yet so utterly ignored by most.

Non-objective painting helps to free the human soul from materialistic contemplation and brings joy through the perfection of esthetic enlightenment. Therefore, Kandinsky was not only a painter and scientist, but

**10**

also a prophet of almost religious significance. The ideal of his art was conceived even before the utter illusion of the density of matter had been proved by science, and before the reality of frequencies and invisible forces had opened the imagination of man to unlimited expectations. The profound truth of Kandinsky's theories at once impressed those who were equally capable of feeling esthetic enjoyment through his paintings and of realizing the importance of Kandinsky's mission at its advent.

Since photography and motion pictures today record all events, situations, or persons for practical or sentimental need, the skill of modern man has been freed from reproduction by hand, thus enabling him to cultivate a higher stage in art expression by following his creative esthetic urge. His eyes have become sensitized to realize the rhythmic life in the span of the in-between—the life that is the essence of a non-objective masterpiece. Such a masterpiece, due to those spiritual qualities, becomes everlastingly appealing in its endless combinations of colours, forms, and contrasts, in their relations to each other or to space. It can be easily observed that each colour and design motive is organized in itself, while constantly re-acting and playing with its form or colour opponent. Thus it brings restful enjoyment, which is as peacefully uplifting as the observance of the infinity of the starlit sky. Out of such pleasures emerges the realization of the rhythm which lies in the in-between, realized by following the motives and discovering the meeting points of lines and forms, in contrast to a calm, harmonious unit.

Contrary to the static form-ideal of painting which prevailed in the past millennium, where the subjective object was immediately perceived as a whole and graphically recorded by the intellect, always directed object-ively earthward, the moving form-ideal of today sets into motion the eye in any desired direction of the rhythmic non-objective creation. This cannot be mentally recorded or memorized like objective impressions because it points heavenward, as an expression of infinity. If to some the harmony of order and beauty of these non-objective creative paintings is not imme-diately obvious or appealing, it gradually becomes evident to anyone permanently exposed to their increasingly realized influence. Through this, the onlooker subconsciously enfolds his personal advance towards exacti-

tude and sense for esthetic beauty, finding it immensely enjoyable and useful. Because the objective painting contacts earthly matter only, it cannot cause such spiritual evolution.

To unfold the human soul and lead it into receptivity of cosmic power and joy is the tremendous benefit derived from the non-objective masterpiece, so intensely useful and conceived from the primary essence of creation. In loving Kandinsky's paintings, we assimilate ourselves with expressions of beauty with which he links us to a higher world. Kandinsky's message of non-objectivity is the message of Eternity.

# FOREWORD

It is perhaps not without interest to remark that the thoughts developed in this small book are an organic continuation of my book, "On the Spiritual in Art." Since I have set out in this direction, I must continue in it.

At the beginning of the World War, I spent three months in Goldach on Lake Constance and employed this time almost exclusively in systematizing both my theoretic ideas, which sometimes had been imprecise, and my practical experience. In this way, a rather large fund of theoretic material was assembled.

This material remained untouched for almost ten years. Not until quite recently has it become possible for me to develop it further. So, this book came into existence.

I have purposely condensed the questions which I have posed concerning the beginning of the Science of Art, but these questions—when developed consistently—pass beyond the boundaries of painting, and finally of art altogether. Here I seek only to point the way, to establish certain analytical methods and, at the same time, to take synthetic values into account.

Weimar 1923
Dessau 1926                                                            Kandinsky

# FOREWORD
# TO THE SECOND EDITION

Since 1914, the tempo of time seems to have been increasing in speed. Inner tensions accelerate this tempo in all spheres familiar to us. One year is possibly the equivalent of at least ten years of a "quiet," "normal" period.

The one year which has elapsed since the appearance of the first edition of this book should be looked upon as the equivalent of ten years. Further advances in the analytical method and, bound up with this, in the synthetic approach of theory and practice—not alone in painting itself, but in other forms of art expression, as well as in the "positive" and "spiritual" sciences —demonstrate the correctness of the principle which forms the basis of this book.

The further development of this book at the present time would have involved the addition of numbers of special examples and comparisons, which would have increased its size to such an extent that, for practical reasons, it had to be abandoned.

Consequently, I decided to leave the second edition unchanged.

Dessau
January 1928                                               Kandinsky

# INTRODUCTION

Every phenomenon can be experienced in two ways. These two ways are not arbitrary, but are bound up with the phenomenon—developing out of its nature and characteristics:

Externally—or—inwardly.

The street can be observed through the windowpane, which diminishes its sounds so that its movements become phantom-like. The street itself, as seen through the transparent (yet hard and firm) pane seems set apart, existing and pulsating as if "beyond."

As soon as we open the door, step out of the seclusion and plunge into the outside reality, we become an active part of this reality and experience its pulsation with all our senses. The constantly changing grades of tonality and tempo of the sounds wind themselves about us, rise spirally and, suddenly, collapse. Likewise, the movements envelop us by a play of horizontal and vertical lines bending in different directions, as colour-patches pile up and dissolve into high or low tonalities.

The work of Art mirrors itself upon the surface of our consciousness. However, its image extends beyond, to vanish from the surface without a trace when the sensation has subsided. A certain transparent, but definite glass-like partition, abolishing direct contact from within, seems to exist here as well. Here, too, exists the possibility of entering art's message, to participate actively, and to experience its pulsating-life with all one's senses.

Aside from its scientific value, which depends upon an exact examination of the individual art elements, the analysis of the art elements forms a bridge to the inner pulsation of a work of art.

The general viewpoint of our day, that it would be dangerous to "dissect" art since such dissection would inevitably lead to art's abolition, originated in an ignorant under-evaluation of these elements thus laid bare in their primary strength.

**17**

**Painting and Other Art Expressions**

In reference to analytical examinations, the art of painting, strangely enough, assumes a special position among the various forms of art expression. Architecture, for example, by its nature closely bound up with utility, consequently requires from its very start a certain degree of scientific capacities. Music, which serves no practical use (with the exception of march and dance music) and which has until now remained abstract, has long developed its theory; perhaps so far it is only one-sided but, nevertheless, it is constantly being developed. Thus these two diametrically opposite forms of art expression have a scientific basis about which no one seems to feel offended.

If in this respect the other art expressions have remained more or less backward, it is always in the degree of development relative to the artistic development.

**Theory**

Painting, especially, has advanced with almost fantastic strides during the last decades, and it has only recently been freed from practical meaning and liberated from the necessity of responding to the many purposes it had earlier been forced to serve. It has attained a level which imperiously demands that an exact scientific examination be made about the pictorial means and purposes of painting. Without such an investigation, further advance is impossible—either for the artist or the general public.

**In Earlier Times**

It can be assumed with complete certainty that painting was not always lacking in theory as it is today. The beginner was taught that certain scientific knowledge formerly existed, not merely covering purely technical matters, but certain principles of composition as well, and that to some extent, facts concerning the elements, their nature and application were general knowledge to the artists.[1]

With the exception of the purely technical recipes (printing, binding media, etc.) of which many have been found only within the last twenty

[1] For instance: the use in composition of the three primary planes as the basis for the construction of a picture. The remnants of these principles were used until quite recently in the art academies, and possibly still are in use today.

years[1] and which, in Germany especially, have played a certain role in the development of colours, very little has been transferred to our time of this earlier knowledge—which may even have represented a highly developed science of art. It is a strange fact that although the impressionists destroyed the last remnants of painting theory in their fight against "academicism," they immediately—though unconsciously—laid the first foundation stone of a new science of art, despite their contention that nature is the only theory for art.[2]

One of the most important tasks which the new science of art could set for itself would be a thorough analysis of the history of art; to determine the elements, construction and composition in various periods—among different people on the one hand and, on the other, to ascertain the growth within the scope of these three questions: the direction, the rate of speed, and the necessity underlying the enrichment and the apparently impulsive development—which possibly pursues a definite evolution such as, perhaps, a wave line. While the first part of this task—the analysis—borders on the problems of the "positive" sciences, the second part—the nature of the development—touches the problems of philosophy. This creates a focal point of lawful measure of the human development in general.

**Art History**

It should be noted in passing that the revealing of the forgotten knowledge of earlier art epochs can be accomplished only with great effort, but this should decisively eliminate the fear of the "dissection" of art. For, if "dead" precepts lie so deeply buried in living works that they only with great difficulty can be brought to light, then their "injurious" effects are nothing other than the fear which arises from ignorance.

**"Dissection"**

---

1 See, for example, the valuable work by Ernst Berger—"Beitrage zur Entwicklungsgeschichte der Maltechnik," 5 parts, Georg D. W. Callwey Verlag, Munich.
In the meantime, a voluminous literature dealing with these questions has sprung up. Recently there appeared that extensive work by Dr. Alexander Eibner—"Entwicklung und Werkstoffe der Wandmalerei vom Altertum bis zur Neuzeit," Verlag B. Heller, Munich.

2 Very soon after this, appeared P. Signac's book: "De Delacroix au Neo-Impressionisme" (published in Germany by Axel Juncker, Charlottenburg, 1910).

**Two Goals**   The researches which must become the cornerstone of the new science—the science of art—have two goals and proceed out of two necessities:

1. the need for science in general which grows spontaneously out of a non- or extra-utilitarian urge to know: the "pure" science, and
2. the need of balance in the creative powers which can be grouped under two schematic heads—intuition and calculation: the "practical" science.

Standing at present at the very beginning of this research, it appears to us today as a labyrinth going off to all sides and disappearing into a distant fog. Since we are absolutely unable to predict its further development, it must be started very systematically, for which a clear plan is necessary.

**Elements**   The first unavoidable question is, naturally, the question of the **art elements,** which are the building materials of works of art and which, as such, must be different in every art.

We must at the outset distinguish **basic elements** from other elements, viz.—elements without which a work in any particular art cannot even come into existence.

The other type of elements must be termed **secondary elements.**

In both cases it is necessary to carry through an organic gradation of the elements.

This book will deal with two basic elements which are the very beginning of every work of painting, and without which this beginning is not possible. At the same time, they constitute the conclusive material for an independent kind of painting—graphic.

We must, therefore, start here with the proto-element of painting—the Point.

The ideal of all research is:

1. precise investigation of each individual phenomenon—in isolation,
2. the reciprocal effect of phenomena upon each other—in combinations,
3. general conclusions which are to be drawn from the above two divisions.

My objective in this book extends only to the first two parts. The material in this book does not suffice to cover the third part which, in any case, cannot be rushed.

The investigation should proceed in a meticulously exact and pedantically precise manner. Step by step, this "tedious" road must be traversed—not the smallest alteration in the nature, in the characteristics, in the effects of the individual elements should escape the watchful eye. Only by means of a microscopic analysis can the science of art lead to a comprehensive synthesis, which will extend far beyond the confines of art into the realm of the "oneness" of the "human" and the "divine."

This, after all, is the perceptible goal, though it nevertheless lies far in the future.

Concerning this special task, I not only lack the strength to carry the initial work through with sufficient exactitude, but lack space, as well. The aim of this small book is merely to point out, in a general and fundamental way, the "graphic" basic elements viewed:

1. "abstractly," i.e. isolated from the objective environment of the material form of the material plane, and
2. on the material plane—the effect of the fundamental characteristics of this plane.

But even this must be restricted to a rather superficial investigation—as an attempt to find a standard method in this scientific research of art and to test it in its use.

POINT

The geometric point is an invisible thing. Therefore, it must be defined as an incorporeal thing. Considered in terms of substance, it equals zero.

Hidden in this zero, however, are various attributes which are "human" in nature. We think of this zero—the geometric point—in relation to the greatest possible brevity, i.e., to the highest degree of restraint which, nevertheless, speaks.

Thus we look upon the geometric point as the ultimate and most singular **union of silence and speech.**

The geometric point has, therefore, been given its material form, in the first instance, in writing. It belongs to language and signifies silence.

In the flow of speech, the point symbolizes interruption, non-existence (negative element), and at the same time it forms a bridge from one existence to another (positive element). In writing, this constitutes its **inner significance.**

Externally, it is merely a sign serving a useful end and carries with it the element of the "practical-useful," with which we have been acquainted since childhood. The external sign becomes a thing of habit and veils the inner sound of the symbol.

The inner becomes walled-up through the outer.

The point belongs to the more confined circle of habitual everyday phenomena with its traditional sound, which is mute.

The sound of that silence customarily connected with the point is so emphatic that it overshadows the other characteristics.

All appearances that are traditionally familiar because of their singular expression, become mute to us. We no longer react to their appeal and are surrounded by silence; so we succumb to the deadly grip of "practical-efficiency."

**Shock**  Sometimes an unusual shock is able to jolt us out of such a lifeless state into vigorous feeling. Frequently, however, the most thorough shaking fails to revitalize the deadly condition. The shocks which come from without (sickness, accident, sorrow, war, revolution) wrench us violently out of the circle of our customary habits for a shorter or a longer time, but such shocks are, as a rule, looked upon as a more or less violent "injustice." Therefore, the desire to re-establish as soon as possible the traditional habits, temporarily abandoned, outweighs all other feelings.

**From Within**  Disturbances originating from within are of a different character; they are brought about by the human being himself and, therefore, find in him their appropriate foundation. This foundation is not the capacity merely to observe the "street" through the fragile—although hard and firm—"pane of glass," but consists of being able to enter the street. There, the receptive eye and the receptive ear transform the slightest vibrations into impressive experiences. Voices arise from all sides, and the world rings.

Just as an explorer penetrates deeply into new and unknown lands, one makes discoveries in the everyday life, and the erstwhile mute surroundings begin to speak a language which becomes increasingly clear. In this way, the lifeless signs turn into living symbols and the dead is revived.

Naturally, the new science of art can only develop when the signs become symbols and the receptive eye and ear open the way from silence to speech. Let him who is unable to accomplish this, leave both the "theoretic" and the "practical" in art alone; far from building a bridge, those efforts spent on art will, rather, enlarge the present day chasm between mankind and art. It is these very people who are today intent upon placing a period after the word "art."

**Release**  As we gradually tear the point out of its restricted sphere of customary influence, its inner attributes—which were silent until now—make themselves heard more and more.

One after the other, these qualities—inner tensions— come out of the depths of its being and radiate their energy. Their effects and influence upon human beings overcome ever more easily the resistances they set up. In short, the dead point becomes a living thing.

We will select two typical cases from many possible ones:

1. Let the point be moved out of its practical-useful situation into an impractical, that is, an illogical, position.

**First Case**

>Today I am going to the movies.
>Today I am going. To the movies
>Today I. Am going to the movies

It is apparent that it is possible to view the transposition of the point in the second sentence still as a useful one—emphasis upon the destination, stress upon the intention, loud fanfare.

In the third sentence the illogical, in pure form, is at work. This may be explained as a typographical error—the inner value of the point flashes forth for a moment and is immediately extinguished.

2. Let the point be moved so far out of its practical-useful situation that it loses its connection with the flow of the sentence.

**Second Case**

>Today I am going to the movies

●

In this case, the point must have considerable open space around it, in order that its sound may have resonance. In spite of this, its sound remains delicate—overpowered by the sound of the print surrounding it.

As the surrounding space and the size of the point are increased, the sound of the print is reduced and the sound of the point becomes clearer and more powerful (Fig. **1**).

**Further Release**

●

Fig. **1**

Thus arises a double sound—print-point—besides the practical-useful association. It is a balancing of two worlds which can never meet or agree. This is a useless, revolutionary state of affairs—the print is shaken by a foreign body which cannot be brought into any relation to it.

**Independ-
ent Being**

Nevertheless, the point has been torn out of its customary state and prepares to leap out of one world into another. In the latter, it frees itself from dependency, from the practical-useful. Here it begins its life as an **independent being** and its subordination transforms itself into an inner-purposeful one. This is the world of painting.

**Through
Collision**

The point is the result of the initial collision of the tool with the material plane, with the basic plane. Paper, wood, canvas, stucco, metal—may all serve as this basic plane. The tool may be pencil, burin, brush, pen, etching-point, etc. The basic plane is impregnated by this first collision.

**Concept**

The point's **external** concept in painting is not precise. The invisible geometric point must assume a certain proportion when materialized, so as to occupy a certain area of the basic plane. In addition, it must have certain boundaries or outlines to separate it from its surroundings.

This goes without saying and appears very simple at first. But even in this simple case, one immediately runs up against inaccuracies which indicate the embryonic state of the art theory of today.

As the **sizes** and shapes of the point change, the relative sound of the abstract point likewise is altered.

**Externally**, the point may be defined as the smallest elementary form, but this definition is not exact. It is difficult to fix the exact limits of the concept "smallest form." The point can grow and cover the entire ground plane unnoticed—then, where would the boundary between point and plane be?

There are two considerations to be borne in mind here:

1. the relation of the size of the point to the size of the plane, and
2. the relative sizes of the point and of the other forms on this plane.

A form which, when on the otherwise empty basic plane, may still be considered to be a point, must be termed a plane when, for example, a very thin line appears with it upon the basic plane (Fig. **2**).

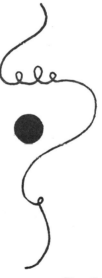

Fig. **2**

The relation of sizes in the first and second case determines the conception of the point which, at present, can be tested on the basis of feeling only—since we lack an exact numerical expression for it.

| | |
|---|---|
| **At the Boundary** | Only by feeling, are we able to determine when the point is approaching its extreme limit and to evaluate this. This approach to the external boundary—indeed, the crossing of it somewhat, the attainment of that moment when the point, as such, begins to disappear and the plane in its stead embarks upon its embryonic existence—this instant of transition is a means to the end. |

In this case, the end is the **veiling** of the absolute sound of the form: the emphasis on its dissolution, the note of imprecision in it, the instability, the positive movement (or the negative, as the case may be), the flickering, the tension, the abnormality in the abstraction, the risk of inner overlapping (the inner sounds of the point and the plane collide with each other, fuse, and then recoil), a dual note in a single form—that is, the creation of a double sound by a **single** form. The multiplicity and complexity in expression of the "smallest" form attained, after all, by slight changes in its size, serve to the receptive mind as a plausible example of

**Abstract Form**

the power and depth of expression of abstract forms. Upon further development of this means of expression in the future, and further development of the receptivity of the observer, more precise concepts will be necessary, and these will surely, in time, be attained through measurement. Expression in numerical terms will here be indispensible.

**Numerical Expression and Formulae**

There resides in this only one danger: that the numerical expression may lag behind the sensory perception and that it may, thereby, inhibit it. A formula is very much like glue. It is also akin to flypaper to which the foolish fall victims. It is like an overstuffed chair which embraces one in its warm arms. On the other hand, the struggle to free oneself from the bonds of usage is the necessary preparation for the further spring to new values and, finally, to new formulae. Even formulae become obsolete, to be replaced by new-born formulae.

**Form**

The second inevitable fact concerns the outer limit of the point which determines its **external form.**

Abstractly or imaginatively, the point is thought of as ideally small, ideally round. In actuality, it is an ideally small circle. Nevertheless, just

as in the case of its size, its limits are equally relative. In its material form, the point can assume an unlimited number of shapes: it can become jagged, it can move in the direction of other geometric forms, and finally develop into entirely free shapes. It can be pointed and tend towards the triangular. Or, prompted by an urge for relative immobility, it can take on the shape of a square. When it has a jagged edge, the elongated projections can be of smaller or larger size and take on a relationship to one another. Here no boundaries can be fixed and the realm of points is unlimited (Fig. 3).

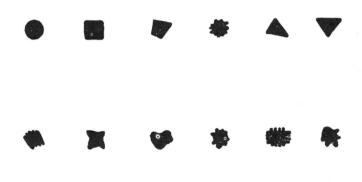

Fig. **3**
Examples of point forms.

Therefore, depending on the size and form, the basic sound of the point is variable. This variability should, nevertheless, be understood in no other sense than as a relative innermost colouration of the basic inner nature, which yet rings its pure tone.

**Basic Sound**

It must, however, always be emphasized that elements completely pure in tone which radiate a single colour do not really exist; that even those elements designated as "basic" or "proto-elements" are not primitive but are, on the contrary, of a complex nature. All concepts having to do with the "primitive" are likewise only relative concepts. Our "scientific" language is, therefore, equally but relative. The absolute we do not know.

**Absolute Concepts**

31

**Inner
Concept**

At the beginning of this chapter, in the course of the discussion of the practical-useful value of the point in written language, the point was defined as a concept linked with the idea of silence of shorter or longer duration.

The **point**, as such, makes a certain **statement** which is organically bound up with the utmost **restraint.**

**The point is the innermost concise form.**

It is turned inwards. It never completely loses this characteristic—even when it assumes, externally, an angular shape.

**Tension**

Its tension is, even in its last analysis, **concentric**—also, in cases where it exhibits eccentric tendencies, whereby arises a double resonance of the concentric and the eccentric.

The point is a small world cut off more or less equally from all sides and almost torn out of its surroundings. Its fusion with the surroundings is minimal, and seems to be non-existent in cases of perfected roundness. On the other hand, it maintains itself firmly in place and reveals not the slightest tendency to movement in any direction whatsoever, either horizontal or vertical. Furthermore, it neither advances nor recedes. Only its

**Plane**

concentric tension discloses its inner kinship with the circle—while its further characteristics rather point to the square.[1]

**Definition**

The point digs itself into the plane and asserts itself for all time. Thus it presents the **briefest, constant, innermost assertion**: short, fixed and quickly created.

Therefore, the point, in its outer and inner sense, is the **proto-element of painting** and especially of the "graphic."[2]

---

[1] For the relationship between colour and form elements consult my article "Die Grundelemente der Form" in "Staatl. Bauhaus 1919-1923," Bauhaus-Verlag, Weimar-Munich, p. 26 and colour plate V.

[2] There is a geometric designation of the point by means of an "O" meaning "origo," that is, "beginning" or "origin." The geometric and the pictorial views coincide.
The point, when looked upon as a symbol, is also termed the "proto-element." ("Das Zeichenbuch" by Rudolph Koch, II Edition, Verlag W. Gerstung, Offenbach a. M., 1926.)

The concept, element, can be understood in two different ways: as an external, and, as an inner concept.

Externally, each individual graphic or pictorial form is an element. Inwardly, it is not this form itself but, rather, the tension within it, which constitutes the element.

In fact, no materializing of external forms expresses the content of a work of painting but, rather, the forces=tensions which are alive within it.[1]

If by some magic command these tensions were to disappear or to expire, the work, which is alive at that very instant, would die. On the other hand, every accidental grouping of several forms could be called a work of art. The content of a work of art finds its expression in the composition: that is, in the sum of the tensions inwardly organized for the work.

This seemingly simple statement has a highly important, fundamental significance: it divides into these two opposing groups not only the present day artists, but the present day men altogether, depending on their acceptance or rejection of it:

1. those persons who recognize not only material things but also the existence of the immaterial or spiritual, and
2. those who choose to accept nothing beyond material evidence.

For the second category, art cannot exist and, consequently, these people today repudiate the very word "art" while seeking a substitute for it.

To my way of thinking, one might distinguish element from "element": that is, the term "element" would signify the form separated from the inner tension, and by element, the tension alive within this form. The elements are, therefore, in reality abstract, while the form is in itself "abstract." If it were actually possible to work with abstract elements, the external form of contemporary painting would become radically

---

[1] See Heinrich Jacoby, "Jenseits von 'musikalisch' und 'unmusikalisch'," Stuttgart, Verlag F. Enke, 1925. Difference between "matter" and "sound-energy" (p. 48).

altered. Nevertheless, this would not mean that painting as a whole would become superfluous: even the abstract elements of painting would retain their pictorial colouration as do the elements of music.

**Time**  Lack of joyous mobility on and off the surface, reduces the time limit of perception to a minimum; the element of time in the point is almost completely eliminated which, in special cases of composition, makes the point inevitable. Its use here corresponds to the sharp blow on a kettle-drum or a triangle in music, or to the short taps of the woodpecker in nature.

**The Point in Painting**  Even at present there exist some art theorists who look askance at the use of point or line in painting. They would like to see the many venerable barriers preserved, which until recently isolated with apparent finality two fields of art from each other—that of painting and that of the graphics. At all events, there exists no **inner** reason for this separation.[1]

**Time in Painting**  Time, in painting, is a question in itself and is very complex. Here as well the barrier began to dwindle several years ago.[2] This barrier hitherto had divided two fields of art—that of painting from that of music.

The apparently clear and justifiable division:
painting—space (plane)
music—time

---

[1] The reason for this division is an external one and it would be more logical, if a more exact definition is necessary, to divide painting into hand-painting and print-painting, which would quite correctly point to the technical origin of art works. The term "graphic" has lost its clarity—it is not uncommon for watercolour to be classified with the graphics which is sufficient proof of the confusion in our thoughtless, habitual use of conceptions. A watercolour painted by hand is a work of painting or, to designate it more exactly, of hand-painting. This same watercolour, reproduced exactly by means of lithography, still is a work of painting but, to be precise, of print-painting. To make a real distinction, one could add the terms "black-and-white" or "colour" painting.
[2] The "All-Russian Academy of the Science of Art" in Moscow, for example, took some steps in this direction in the year 1920.

has upon closer, though yet hasty, examination suddenly become doubtful and, as far as I know, this first became apparent to the painters.[1] The tendency to overlook the time element in painting today still persists, revealing clearly the superficiality of prevailing art theory, which noisily rejects any scientific basis. This is not the place to cope with this question at greater length—yet a few considerations which throw a clear light upon this time element must be emphasized.

**The point is temporally the briefest form.**

In theory, the point, which is

1. a complex (size and form) and
2. a sharply-defined unit,

should constitute to some degree its relationship with the basic plane as a sufficient means of expression. Theoretically, a work of art can, in its final analysis, consist of a point. This should not be looked upon as an idle statement.

When, today, the theorist (who often proves to be a "practicing" painter as well) attempts to systematize the art elements and is compelled to take special pains to separate and investigate the basic elements, he also has to consider the question of how these elements are to be used, as well as the number necessary for a work of art, even if purely theoretic in character.

This relates to the great, but still veiled, question of the theory of composition. Here, too, one must proceed in a consistent and schematic manner and must start at the beginning. This book is intended to present only a short analysis of the two primary form elements, and to suggest the connection with the general scientific working programme in pointing the direction to a general science of art.

**Number of Elements in an Art Work**

---

[1] When I finally became converted to abstract art, the time element in painting became incontestably clear to me and since then I have used it in practice.

In this sense, we will treat the question which has been raised as to whether or not a point suffices to form a work of art.

We have here various cases and possibilities.

The simplest and briefest is that of the centrally-placed point—of the **point** lying **in the center** of a surface which is square in shape (Fig. **4**).

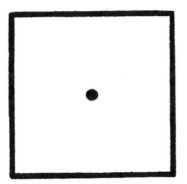

Fig. **4**

**Prototype**
The restriction of the basic effect of the plane here becomes intensified and this constitutes a unique case.[1] As the double sound—point, plane—takes on the character of a **single sound**, the sound of the plane is relatively too slight to be noticeable. This, on the road to simplification, is the last stage in the progressive dissolution of multiple and double sounds through elimination of all complicated elements—reducing the composition to the single proto-element. This, therefore, represents the **prototype of pictorial expression.**

[1] This observation will be clarified more fully in the section of the book which deals with the basic plane.

My definition of the concept "composition" is as follows:

**A composition is the inwardly-purposeful subordination**
1. of the individual elements and
2. of the build-up (construction)
**toward the goal of concrete pictoriality.**

Also, when a single sound completely embodies the pictorial aim, this single sound must be considered the equivalent of a composition. The single sound here is a composition.[1]

When the differences in compositions are considered externally, the pictorial aims, exclusively, are to be equated with the numerical differences. These are quantitative differences, while it goes without saying that in the case of the "prototype of pictorial expression," the qualitative element is completely lacking. When the work of art is estimated on a decidedly **qualitative basis**, a double sound at least is necessary to the composition. This is one of the cases which clearly emphasizes the difference between external and inner measures and means. We find upon closer examination that altogether pure double sounds never really occur; this statement must remain an assertion only, to be proven later. At all events, a composition can be created on a qualitative basis only through the use of multiple sounds.

At the moment the point is moved from the center of the basic plane—eccentric structure—the double sound becomes audible:

1. absolute sound of the point,
2. sound of the given location in the basic plane.

This second sound, which in the case of the centric structure was almost silenced, again becomes distinct and transforms the sound of the point from the absolute to the relative.

---

1 Bound up with this question is a special "modern" question "Can a work be created by purely mechanical means?" In cases of the most primitive numerical problems, this must be answered in the affirmative.

A counterpart of this point on the basic plane will produce a still more complex result. Repetition is a potent means of heightening the inner vibration and is, at the same time, a source of elementary rhythm which, in turn, is a means to the attainment of elementary harmony in every form of art. Aside from this, we have to deal here with two double sounds: every part of the basic plane has a sound peculiar to itself and an individual inner colouration. As a result, facts of apparently little importance produce consequences of unexpected complexity.

The inventory of the given example is:
Elements:    two points + plane.
Result:       1. inner sound of a point,
             2. repetition of the sound,
             3. double sound of the first point,
             4. double sound of the second point,
             5. sound of the sum of all these sounds.

Since, moreover, the point is a complex unit (its size plus its shape), it is easy to imagine what a storm of sounds can develop from a continuing accumulation of points on the basic plane—even when these points are identical; and how this turmoil develops and spreads out, while its further course points to the ever-growing disparity in the size and form of the points which are projected upon the plane.

**Nature**

Also, in nature's unmixed realm, this accumulation of points occurs frequently; it is invariably purposeful and organically necessary. These nature forms are in reality small space particles and carry the same relationship to the abstract (geometric) point as to the pictorial. However, the whole "world" can, on the other hand, be looked upon as a self-contained cosmic composition which, in turn, is composed of an endless number of independent compositions, always self-contained even when getting smaller and smaller. In the final analysis, all of these—large or small, have been

Fig. **5**
Star cluster of Hercules. (Newcomb-Engelmann's
"Popul. Astronomie," Leipzig, 1921, p. 294.)

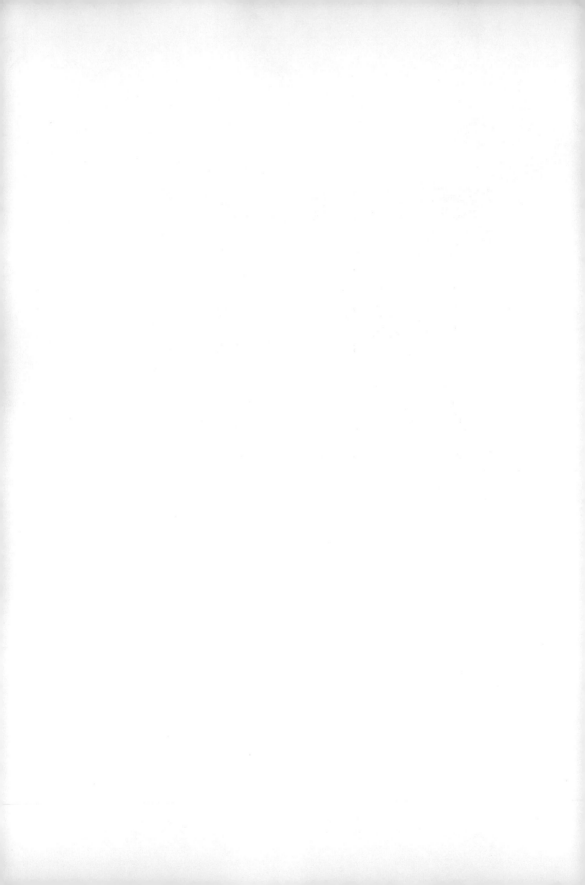

originated from points, to which point—in its original geometric essence—everything returns. These are complexes of geometric points which, in various configurations determined by physical laws, float in geometric infinity. The smallest, self-contained, wholly centrifugal shapes actually appear to the naked eye as points seemingly loosely related to each other. Many seeds appear like this. In opening the beautiful, highly-polished, ivory-like head of the poppy (in reality a somewhat large spherical point), we discover heaps of cold blue-grey points arranged according to physical law so as to form an ordered composition, and which carry within themselves the latently dormant generative power, as powerful as the pictorial point.

Frequently, such forms arise in nature through the dismemberment and decomposition of the above-mentioned complexes—the beginning, so to speak, of a return to the primordial form of the geometric state. If the desert is a sea of sand made up entirely out of points, the effect of the uncontrollably-violent tendency of these "dead" points to shift is, not without reason, terrifying.

And so also in nature, the point is a self-contained thing, full of possibilities (Figs. 5 and 6).

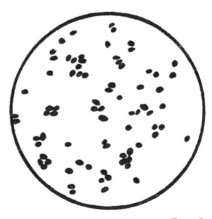

Fig. 6
Nitrate-forming nodule, enlarged 1000 times.
("Kultur d. Gegenwart," part III, section IV, 3, p. 71.)

**Other Art Expressions**

Points are to be met with in all of the art expressions and certainly artists will become increasingly conscious of their inner power. This significance should not be overlooked.

**Sculpture and Architecture**

In **sculpture** and **architecture**, the point results from a cross-section of several planes—it is the termination of an angle in space and, on the other hand, the originating nucleus of these planes which can be guided back to it or can be developed out of it. In Gothic buildings, points are sharply emphasized, frequently by plastic means. In Chinese buildings, this is accomplished with means of equal clarity as curves leading to the point—in short, precise beats audible as a transition of dissolution in which the space form fades away into the atmosphere surrounding the building. Especially in the case of such buildings can we assume a conscious use of the point, since the architectural masses are divided systematically into points whose tendency in composition is to lead toward the highest peak. Peak = point (Figs. **7** and **8**).

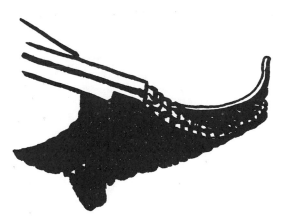

Fig. **7**
Ling-ying-si Gate.
("China" by Bernd Melchers, vol. 2, Folkwang Verlag, Hagen i. W., 1922.)

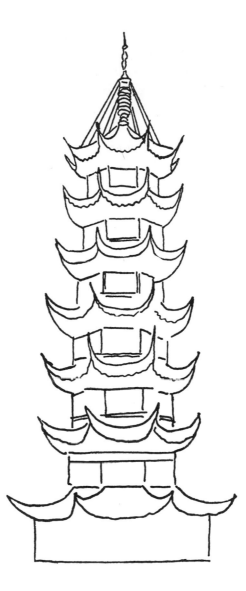

Fig. **8**

"Pagoda of the Dragon Beauty" in Shanghai (built in 1411).

**The Dance**     Already in the classical **ballet form** existed "points" — a designated terminology which unquestionably is derived from "point." The rapid running on the toes leaves behind on the floor a trace of points. The ballet dancer leaps to a point above, clearly aiming at it with his head and, in landing, again contacts a point on the floor. High leaps in the **modern dance** can, in some cases, be compared with the "classic" ballet's high leap; that, whereas the leap formerly pointed to a straight, vertical direction, the "modern" leap frequently forms a five-pointed plane with its five extremities—head, two feet and two hands, whereby the ten fingers form ten smaller points (e.g., the dancer Palucca, Fig. **9**). Furthermore, the brief states of rigid immobility can be looked upon as points. Thus we have active and passive point formations which bear a relationship to the musical form of the point.

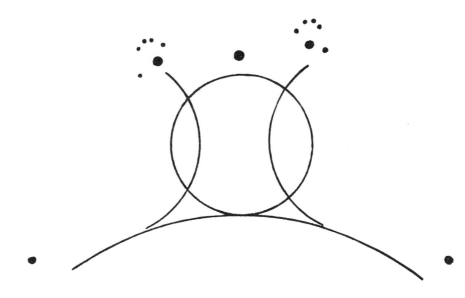

Fig. **10**

Graphic diagram of the leap shown in the photograph opposite, Fig. **9**.

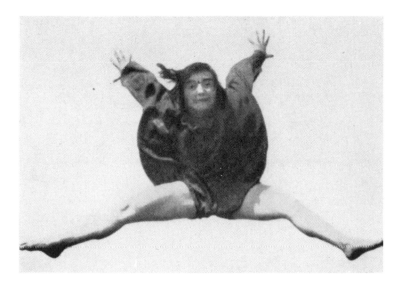

Fig. **9**

A leap of the dancer Palucca.

In addition to the beating of the kettle-drum and striking of the triangle, of which we have already spoken, points can be produced in music with all sorts of instruments—especially the percussion instruments. The piano, however, enables the creation of finished compositions exclusively by means of the combination and the sequence of tonal points.[1]

Strings and piano

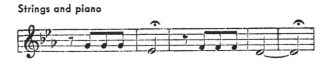

Beethoven's 5th Symphony (the first measures).

Fig. **11**
The above music translated into points.

[1] It is clearly evident that certain musicians also have been more or less consciously attracted by the magnetic power of the point, which can be distinctly recognized through its inner tension as demonstrated by the so-called subconscious "hallucination" of Bruckner, whose meaning had been detected and described: "How could this (his interest in the effect of points after signatures or on doorplates) have been a derangement of his spirit, when it seems that it was no wandering mind which investigated these points—especially if one understands Bruckner's nature and the manner in which he searched for knowledge as indicated in his studies of the theory of music? It becomes apparent that psychological significance resides in the fact that he was attracted to the reclining proto-unit of all spatial expansion's origin. He sought everywhere for the ultimate inner points, to reach this final analysis out of which, in his opinion, originates the infinity of vast dimensions, impossible without its originating extension point." "Bruckner" by Dr. Ernst Kurth, vol. I, p. 110, footnote. Max Hesses Verlag, Berlin.

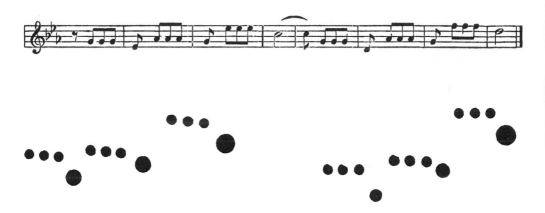

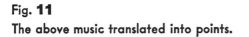

**Fig. 11**

The above music translated into points.

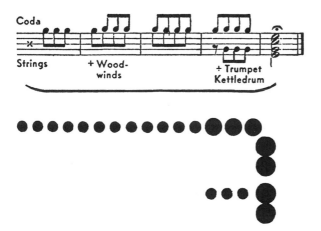

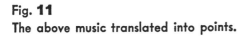

**Fig. 11**

The above music translated into points.

**44**

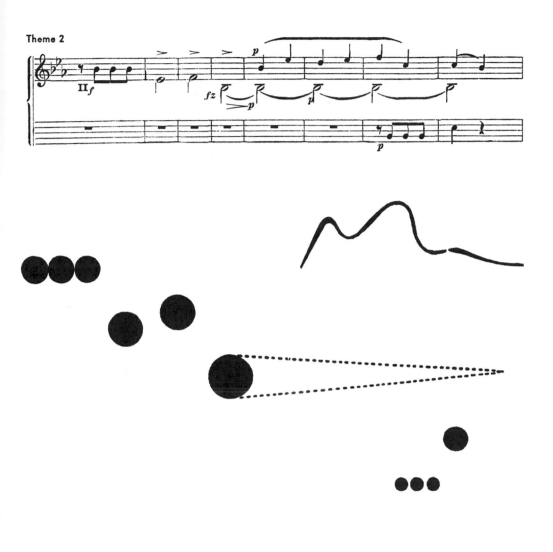

Fig. **11** [1]
Theme 2 translated into points.

---

[1] In making these translations, I received the valuable aid of Music Superintendent
Franz v. Hoesslin and for this I extend to him my heartfelt gratitude.

| | |
|---|---|
| **Graphic Art** | In that particular field of painting known as **graphic**, the point develops its autonomous powers with special clarity: the material tools offer to these powers many different possibilities in the way of diversity of form and size, which establishes the point in countless entities with different sound values. |
| **Techniques** | Even here, this multiplicity and diversity are easily classified when the special characteristics of the graphic techniques are used in this classification. |
| | The typical graphic techniques are: |
| | 1. etching, particularly dry-point, |
| | 2. the woodcut, and |
| | 3. lithography. |
| | The differences between these three techniques stand out with exceptional clarity in connection with the point and its creation. |
| **Etching** | In **etching**, naturally, the smallest black point can be obtained with the greatest of ease while, on the other hand, only with considerable effort and various tricks can a large white point be obtained. |
| **Woodcut** | The situation in the **woodcut** is entirely opposite. The smallest white points need only one stab. It is the large black point which demands effort and consideration. |
| **Lithography** | In **lithography** both roads are equally smooth and effort is eliminated. |
| | Likewise, the possibilities of making corrections differ in these three techniques: in etching, strictly speaking, correction is impossible; in the woodcut it is restricted and, in lithography, it is unlimited. |
| **Atmos- phere** | It should be evident from this comparison of the three techniques, that the lithographic process was bound to be the last discovered; in fact, since the discovery did not take place until "today," facility cannot be attained without effort. On the other hand, ease in creating and ease in correcting are characteristics which are particularly suited to the present day. The |

**46**

present day is only a springboard to "tomorrow" and only in this role can it be accepted with innermost tranquility.

No natural difference can or should remain superficial—it must point to the profound depth, that is, to the inner life of things. Likewise, technical possibilities grow in just as functional and purposeful a manner as any other potentiality, whether it be in "material" life (spruce tree, lion, star, louse) or in the spiritual realm (art work, moral principle, scientific method, religious idea).

**Root**

Even though on the surface the individual appearances of plants differ so greatly from each other that their inner relationship remains obscured— even though these phenomena seem chaotic to the superficial eye—they can, nevertheless, on the basis of their common **inner necessity**, be traced back to the same root.

**False Ways**

It is in this manner that one learns the value of differences which, although they always are originally purposeful and well-founded, avenge themselves frightfully in monstrous abortions when they are handled in a frivolous manner.

This simple fact can readily be observed in the more restricted field of the graphics—the failure to understand the basic differences in the above-mentioned technical potentialities has repeatedly lead to useless and, therefore, repulsive works. They owe their existence to the inability of recognizing the inner life behind the external appearance of things—the soul, hardened like an empty nutshell, has lost its capacity to penetrate any longer the depths of things where the pulsebeat, beneath the outer husk, becomes audible.

The specialists of 19th Century graphics were not infrequently proud of their ability to make a woodcut resemble a pen drawing, or a lithograph look like an etching. Works of this sort can be designated only as testimonials of spiritual poverty. The cock's crowing, the door's creaking, the dog's barking, however cleverly imitated on a violin, can never be estimated as artistic accomplishments.

| | |
|---|---|
| **Means** | Hand-in-hand with the **materials** and **tools** of these three techniques goes, naturally, the necessity of realizing the three different characteristics of the point. |
| **Material** | While paper can be used as material for these three different techniques, the relation of the particular tool in each case is fundamentally different. This accounts for the continued existence, side by side, down to the present day of these three techniques. |
| **Tools and Origin of the Point** | Of the various kinds of etching, **drypoint** is used by preference today because It harmonizes especially well with the present day atmosphere of haste, and because it possesses the incisive character of precision. The basic plane can here remain entirely white, and in this white the points and lines lie deeply and sharply embedded. The etching-needle works definitely and with the greatest determination and bores eagerly into the plate. The point is created first in the negative through a short, precise prick in the plate. |

The needle is pointed metal—cold.
The plate is smooth copper—warm.

The colour is applied thickly on the entire plate and wiped off in such a manner that the small point remains lying simply and naturally in the lap of brightness.

The pressure of the press is powerful. The plate eats its way into the paper. The paper penetrates the smallest depressions and tears out the colour. It is an impassioned process which leads to the complete fusion of the colour with the paper.

Thus, the small black point—the pictorial proto-element—is here created.

**Woodcut:**
Tools: a plane made of metal—cold.
Plate: of wood (e.g., boxwood)—warm.

The point is created in such a way that the instrument does not touch it—the point is encircled—like a fortress—with a ditch, and great care is taken not to injure it. In order that the point may enter the world, it is necessary to do violence to its entire surroundings; to tear them out and destroy them.

The colour is rolled onto the surface in such a way that it covers the point and leaves the surrounding area free. The future print can already be clearly seen upon the block.

The pressure of the press is light—the paper must not make its way into the depressions, but must remain upon the surface. The small point does not sit in the paper, but on the paper. It remains for its inner forces to claw their way into the surface.

## Lithography:
The plate: stone, clay of an indefinable yellow—warm.

The tools: pen, crayon, brush, any more or less pointed object with surfaces of contact of the most varied sizes. Lastly, a fine atomizer (spray technique). Great diversity, great flexibility.

The colour rests lightly and insecurely. Its union with the block is very loose and it can easily be removed by grinding—the stone returns immediately to its original chaste condition.

The point is there in a moment—with the speed of lightning, without effort and loss of time—only a brief, superficial contact.

The pressure of the press—fleeting. The paper touches impartially the entire block and reflects only the parts which have been fructified.

The point sits so lightly upon the paper that it would not be surprising if it were to fly off it.

This is the way the point sits:
in the etching—in the paper,
in the woodcut—in and on the paper,
in the lithograph—on the paper.

49

It is in this manner that the three graphic techniques differ from each other, and in this manner that they are mutually interwoven.

Thus, the point—remaining always a point—takes on different aspects and is, thereby, a changing expression.

**Texture**     These last remarks relate to the special question of **texture.**

The term "texture" signifies the manner in which the elements are externally combined with each other and with the basic plane. This mode of combination depends on three factors which may be classified schematically as follows:

1. according to the character of the given space which may be smooth, rough, flat, plastic, etc.,
2. according to the type of tool, whereby the one in common use today in painting—the brush of various types—may be supplanted by other tools, and
3. according to the manner of application: the colour may be laid on loosely, compactly, by stippling, by spraying, etc., depending upon its consistency—this accounts for the difference in binding media, pigments, etc.

Even in the very limited field of the point, attention should be given to texture possibilities (Figs. **12** and **13**). Despite the narrowly drawn confines of this smallest of elements, the different means of producing it are, nevertheless, of importance, since the sound of the point takes on each time a different colouration in accordance with the manner of its creation.

We have, therefore, to consider:
1. the character of the point as determined by the tool used to make it in combination with the nature of the surface receiving it (in this case, the type of plate),
2. the character of the point in the way of its union with the surface finally receiving it (in this case, the paper),
3. the character of the point as it depends upon the qualities of this definite surface itself (in this case, smooth, granular, striated, rough paper).

Fig. **12**
Concentric complex of points of free form.

When a piling-up of points is necessary, the three cases just cited will become still further complicated by the manner of producing this accumulation of points—whether this accumulation be created directly by hand or by more or less mechanical means (all sorts of spray techniques).

Fig. **13**
A large point formed out of small points (spray technique).

Naturally, all of these possibilities play a still greater role in painting;[1] the difference here lies in the individuality of the pictorial means which offers infinitely more possibilities for texture than the narrow field of the graphics.

---

[1] This question cannot be discussed more at length here.

Nevertheless, even in this restricted realm, considerations of texture retain their full significance. Texture is a means to an end and it must be looked upon as such and so used. In other words, texture must not become an end in itself; it must serve the idea residing in the composition (purpose), just as does every other element (means). Otherwise, an inner disharmony arises in which the means drown out the end. The external has taken over the inner—mannerism.

In this case may be seen one of the differences between "objective" and abstract art. In the former, the sound of the element "in itself" is veiled, thrust back; when abstract, it attains its full, unveiled sound. The small point, especially, is able to give incontestable testimony of this.

**Abstract Art**

In the field of the "objective" graphic, there are prints composed entirely of points (a famous "Head of Christ" can be mentioned as an example) in which the points are intended to produce the effect of lines. It is clear that this is an unjustifiable use of the point, since the latter, stifled by the representation and with its inner sound weakened, is condemned to a poverty-stricken half-life.[1]

For the abstract, a certain technique can, of course, serve a definite purpose and be necessary to the composition. Proofs of this are self-evident.

Everything which in very general terms has been said here about the point, has to do with the analysis of the self-contained, stationary point. Changes in its size bring with them corresponding changes in its character. In this

**Force from Within**

---

[1] A quite different case is the division of a surface into points which is dictated by technical necessity as, for example, in zincography, where the division of the surface into points by the screen is unavoidable—the point is not intended here to play an independent role and, to the extent that the technique permits this, it is deliberately repressed.

case, however, it grows out of itself; out of its own center; and only a relative diminuation of its concentric tension results.

**Force from Without**   There exists still another force which develops not within the point, but outside of it. This force hurls itself upon the point which is digging its way into the surface, tears it out and pushes it about the surface in one direction or another. The concentric tension of the point is thereby immediately destroyed and, as a result, it perishes and a new being arises out of it which leads a new, independent life in accordance with its own laws. **This is the Line.**

# LINE

The geometric line is an invisible thing. It is the track made by the moving point; that is, its product. It is created by movement—specifically through the destruction of the intense self-contained repose of the point. Here, the leap out of the static into the dynamic occurs.

The line is, therefore, the **greatest antithesis** to the pictorial proto-element—the point. Viewed in the strictest sense, it can be designated as a secondary element.

The forces coming from without which transform the point into a line, can be very diverse. The variation in lines depends upon the number of these forces and upon their combinations.

**Origin**

In the final analysis, all line forms can be reduced to two cases:

1. application of one force and
2. application of two forces:
   a) single or repeated, alternate action of both forces,
   b) simultaneous action of both forces.

**I A.** When **a force coming from without** moves the point in any direction, the first type of line results; the initial direction remains unchanged and the line has the tendency to run in a straight course to infinity.

**Straight Line**

This is the **straight line** whose tension **represents the most concise form of the potentiality for endless movement.**

For the concept "movement," which is used almost everywhere, I have substituted the term "tension." The customary term is inexact and thereby leads us down the wrong roads and is the cause of further terminological misconceptions. "Tension" is the force living within the element and represents only one part of the creative "movement." The second part

is the "direction," which is also determined by the "movement." The elements of painting are material results of movement in the form:

1. of the tension, and
2. of the direction.

This division creates, furthermore, a basis for the differentiation of various kinds of elements as, for example, point and line. Of these, the point carries only one tension within it and it can have no direction; the line definitely shares in both the tension and the direction. If, for instance, the straight line were to be investigated from the standpoint of its tension alone, it would be impossible to distinguish a horizontal line from a vertical. The above holds equally true in connection with colour analysis, since some colours are to be distinguished from others only in the directions of their tensions.[1]

We note that there are three typical kinds of straight lines of which other straight lines are only variations.

1. The simplest form of the straight line is the **horizontal.** In the human imagination, this corresponds to the line or the plane upon which the human being stands or moves. The horizontal line is also a cold supporting base which can be extended on the level in various directions. Coldness and flatness are the basic sounds of this line, and it can be designated as **the most concise form of the potentiality for endless cold movement.**

---

[1] See, for example, the characterization of yellow and blue in my book "Uber das Geistige in der Kunst," R. Piper & Co., Verlag, Munich, 3rd Edition, 1912, pp. 73, 76, 77 and Plates I and II. [This book has recently been translated into English and reissued under the title "On the Spiritual in Art" by the Solomon R. Guggenheim Foundation, New York City, and this particular reference will be found on pages 60 to 64, incl.] A cautious use of these concepts is especially important in the analysis of "form in drawing," since it is right here that direction plays a definite role. It is to be observed with regret that painting is least well provided with an exact terminology which renders scientific work exceedingly difficult and sometimes quite impossible. One must start here from the beginning and a dictionary of terminology is a necessary preliminary. An attempt at this was made in Moscow about 1919 but has achieved no results. Perhaps the time was not then ripe.

2. In complete contrast to this line, in both an external and inner sense, is the **vertical** which stands at right angles to it, and in which flatness is supplanted by height, and coldness by warmth. Therefore, **the vertical line is the most concise form of the potentiality for endless warm movement.**

3. The third type of straight line is the **diagonal** which, in schematic form, diverges from both of the above at the same angle and, therefore, has the same inclination to both of them; a circumstance which determines its inner sound—equal union of coldness and warmth. Therefore, **the diagonal line is the most concise form of the potentiality for endless cold-warm movement** (Figs. **14** and **15**).

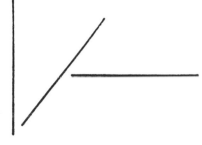

Fig. **14**
Basic types of geometric straight lines.

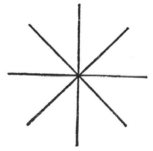

Fig. **15**
Diagram of basic types.

These three types are the purest forms of straight lines and they are differentiated from each other by **temperature:**

**Tempera-
ture**

**Endless movement.**

1. cold form,
2. warm form,
3. cold-warm form.

Most concise forms of the potentiality for endless movement.

To a greater or smaller extent, all other straight lines are only deviations from the diagonal. The differences in a greater or lesser tendency to coldness or to warmth determine their inner sounds (Fig. **16**).

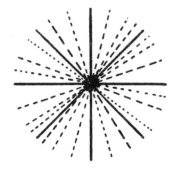

Fig. **16**
Diagram of deviations in temperature.

In this way is formed the star of straight lines which are organized about a common meeting-point.

**Plane Formation**

This star can become ever denser and denser so that the intersections form a more compact center, in which a point develops and seems to grow. This is the axis about which the lines can move and, finally, flow into one another; a new form is born—a plane in the clear shape of a circle (Figs. **17** and **18**).

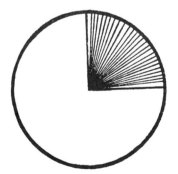

Fig. **17**
Condensation.

Fig. **18**
Circle as result of condensation.

It may be remarked briefly, that in this case we have to do with a special characteristic of the line—its power to create a plane. This power expresses itself here in the same manner that a shovel creates a plane with the incision-like lines it cuts into the earth. Moreover, the line can by still another method produce a plane, but of this I will speak later.

The difference between the diagonals and the other diagonal-like lines, which one could with justification call **free straight lines,** is also a temperature difference as the free straight lines can never attain a balance between warmth and coldness.

Free straight lines can, thereby, lie upon a given plane with a common center (Fig. **19**), or lie outside of the center (Fig. **20**); accordingly, they can be divided into these two classes:

4. **Free straight lines** (unbalanced lines):
    a) centric, and
    b) acentric.

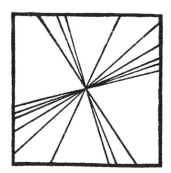

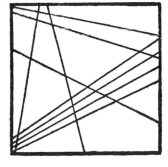

<div align="center">

Fig. **19**
Free straight lines, centric.

</div>

<div align="center">

Fig. **20**
Free straight lines, acentric.

</div>

| | |
|---|---|
| **Colour: Yellow and Blue** | The acentric free straight lines are the first straight lines to possess a special capacity—a capacity which they share to a degree with the "colourful" colours, and which distinguishes the latter from black and white. **Yellow** and **blue**, especially, carry within them different tensions—tensions of advancing and retreating. The purely schematic straight lines (horizontals, verticals and diagonals—but especially the first two), develop their tensions **on** the plane and exhibit no inclination to leave it. In the case of free straight lines and, above all, the acentric ones, we observe a loose relationship to the plane: they are less completely fused with the plane and seem to pierce it occasionally. These lines are farthest removed from the point, which claws itself into the plane, since they especially have abandoned the element of rest.

In the case of the **bounded plane**, this loose relationship is possible only when the line lies freely on it; that is, when it does not touch its outside boundaries. This will be discussed at greater length in the chapter "Basic Plane."

At all events, there is a certain relationship in the tensions of the acentric free straight lines and those of the "colourful" colours. The natural connections between the "graphic" and the "pictorial" elements, which we can to some extent recognize today, are of immeasurable importance to the future theory of composition. Only in this direction, can planned exact experiments in construction be made in our laboratory work, and the mischievous fog in which we are today condemned to wander, will certainly become more transparent and less suffocating. |
| **Black and White** | When the typical straight lines, principally the horizontals and verticals, are tested for their colour characteristics, a comparison with **black** and **white** forces itself, logically enough, upon our attention. Just as both of these colours (which until recently were called "non-colours" and which today are somewhat ineptly termed "colourless" colours) are silent colours, both of the above mentioned straight lines are, in the same manner, silent lines. Here and there, the sound is reduced to a minimum: silence or, rather, scarcely audible whispering and stillness. Black and white lie outside |

of the colour wheel.[1] Horizontals and verticals occupy a special place among lines because, when in a central position, they cannot be repeated and are, therefore, solitary. If we examine black and white from the standpoint of temperature, we find white more apt to be warm than black and that absolute black is inwardly unquestionably cold. It is not without reason that the horizontal scale of colours runs from white to black (Fig. **21**):

| White | Yellow | Red | Blue | Black |

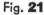

Fig. **21**

A gradual, natural sliding-downward from above to below (Fig. **22**).

In addition in the case of white and black, the elements of height and depth can be noted as coinciding with vertical and horizontal.

"Today" human beings are completely absorbed with the external; the inner is dead for them. This is the last step of the descent, the end of the blind alley. In former times, such places were called "abysses;" today the modest expression "blind alley" suffices. The "modern" individual seeks inner tranquility because he is deafened from outside, and believes this quiet to be found in inner silence. Out of this, in our case, has come the exclusive preference for the horizontal-vertical. The further logical consequence would be the exclusive preference for black and white, indications

---

**1** See "On the Spiritual in Art," where I call black the symbol of death and white, of birth. The same thing can with complete justification be said about the horizontal and the vertical—low and high. The former is lying; the latter is standing, walking, moving about, finally climbing upward. Supporting—growing. Passive—active. Relatively: feminine—masculine.

White

Yellow

Blue

Red

Black

Fig. **22**
Graphic representation of the descent.

of which have already appeared several times in painting. But the exclusive association of the horizontal-vertical with black and white has still to take place; then everything will be immersed in inner silence, and only external noises will shake the world.[1]

These relationships, which are not to be understood as wholly equivalent values but, rather, as inner parallels, may be arranged in the form of a table such as the following:

[1] A strong reaction is to be expected to this exclusiveness, but it will not be in the form of seeking refuge in the past as is, to some extent, the case today. The flight into the past has been frequently in evidence during the last decades—Greek "Classic," Italian Quattrocento, the later Rome, "primitive" art (including "wild beasts"); now, in Germany—German "old masters," in Russia—the icons, etc., in France—discreet looking backward from "today" to "yesterday," in contrast to the attitude of certain Germans and Russians who descend into the profound depths. The future seems empty to the "modern" human being.

| Graphic Form. | Pictorial Form. |
|---|---|
| **Straight Line:** | **Primary Colours:** |
| 1. horizontal, | black, |
| 2. vertical, | white, |
| 3. diagonal, | red (or grey, or green),[1] |
| 4. free straight line. | yellow and blue. |

The parallel: diagonal—**red** is here advanced as an assertion, the detailed proof of which would lead too far afield from the subject of this book. It may only briefly be stated: red[2] is distinguished from yellow and blue by its characteristic of lying firmly on the plane, and from black and white by an intensive inner seething—a tension within it. The diagonal reveals this difference from free straight lines: that it lies firmly on the plane; and this difference from horizontals and verticals: that it has a greater inner tension.

**Red**

The point resting in the center of a square plane was defined above as the harmonizing of the point and the plane, and the total picture designated as the prototype of pictorial expression. A horizontal and vertical in a central position on a square plane would constitute a further complication of this case. These two straight lines are, as has already been said, things living solitary and alone, since they know no repetition. They therefore develop a strong sound which can never be completely drowned out and, thereby, represent the **proto-sound of straight lines.**

**Proto-Sound**

---

1 Red, grey and green, in certain relationships, can be placed on a parallel with each other: red and green—transition from yellow to blue; grey—from black to white, etc. This belongs in the field of colour theory. Suggestions concerning this are to be found in "On the Spiritual in Art."
2 See "On the Spiritual in Art," pp. 69 and 70.

This construction is, consequently, the **prototype of linear expression** or, of linear composition (Fig. **23**).

Fig. **23**

It consists of a square divided into four squares, the most primitive form of the division of a schematic plane.

The sum of the tensions, consisting of 6 elements of cold rest and 6 elements of warm rest=12. Therefore, the next step from the schematic point picture to the schematic line picture is reached through a surprisingly great increase of the means: a single sound is powerfully amplified to 12 sounds. These 12 sounds, on the other hand, consist of 4 sounds of the plane + 2 sounds of the line=6. The combination has doubled these 6 sounds.

This example, which is really part of the theory of composition, was given here with the intention of suggesting the reciprocal effect of the simple elements in elementary combinations, where the expression "elementary" —in an imprecise, flexible sense—reveals the "relativity" of its nature.

This means that it is not easy to fix a limit for the complex and to use the elementary exclusively. Nevertheless, these experiments and observations offer the only means of getting to the bottom of pictorial things which serve the ends of composition. This method is employed by science itself, and has thereby attained—despite excessive one-sidedness—a primarily external order and continues today with the aid of keen analysis to forge its way through to primary elements. In this manner it has, after all, placed before philosophy a rich and well-ordered body of material which—sooner or later—will lead to synthetic results. The science of art must travel the same road, in the course of which, however, it should from the very outset unite the external with the inner.

**The Lyric and the Dramatic**

During the gradual transition from horizontal to free acentric lines, the cold lyric character is transformed into an ever warmer one until it finally acquires a certain dramatic flavor. The lyric quality, nevertheless, remains dominant. The entire field of straight lines is lyric, a fact which can be explained by the effect of a single force from the outside. The dramatic (and in the cases mentioned, the acentric) carries within it—aside from the sound caused by relocation—the sound of collision as well, for which at least two forces are necessary.

The action of two forces in the realm of the line can take place in two ways:

1. the two forces alternate with each other        alternate action,
2. the two forces act together        simultaneous action.

It is evident that the second process is more temperamental and, thereby, "hotter," especially since this process can be looked upon as the result of the action of many alternating forces.

Correspondingly, the dramatic effect mounts, until at last purely dramatic lines come into existence.

Thus the realm of lines embraces all the expressive sounds from the cold lyric in the beginning, to the hot dramatic at the end.

**Linear Translation**  Of course, every phenomenon of the external and of the inner world can be given linear expression—a kind of translation.[1]

The results corresponding to the two categories are:

|  | **Forces:** | **Products:** |
|---|---|---|
| **Point** | 1. two alternate, | angular lines. |
|  | 2. two simultaneous, | curved lines. |

**Angular Lines**

**I B.  Angular Lines.**
Since angular lines are composed of straight lines, they belong under heading I and are placed in the second class under the heading B.

Angular lines originate from the pressure of two forces in the following manner (Fig. **24**):

---

1 Aside from intuitive translations, systematic laboratory experiments should be made in this direction. It would be advisable to investigate first the lyric or dramatic content of every phenomenon chosen for translation, and then to seek in the corresponding linear realm, a form suitable to the given case. Furthermore, an analysis of the already existing "translated works" would throw a strong light on this question. There are numerous examples of such translations in music: musical "pictures" derived from natural phenomena, musical form for works of other arts, etc. The Russian composer, A. A. Schenschin, has made extremely valuable experiments in this direction—"Années de Pélérinage" by Liszt which relates to Michael Angelo's "Pensieroso" and Raphael's "Sposalizio."

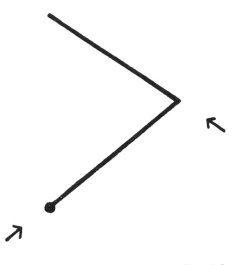

Fig. **24**

**I B I.** The **simplest** forms of angular lines consist of two parts, and are the result of two forces which have discontinued their action after a single thrust. This simple process leads, moreover, to an important difference between straight and angular lines: the angular line is in much closer touch with the plane, and it already carries something plane-like within it. The plane is in the process of creation, and the angular line becomes a bridge. The differences between the countless angular lines depend entirely upon the sizes of the angles, in accordance with which they can be divided into three typical groups:

a) with acute angles — 45°
b) with right angles — 90°
c) with obtuse angles — 135°
  The remainder are atypical acute or obtuse angles, and deviate from the typical in the number of their degrees. Thus, with the first three angular lines, a fourth—an atypical angular line—can be included.
d) with a free angle,
  because of which this angular line must be designated as a free angular line.

**Angles**

**69**

The right angle stands unchangeable in size but is able to change its direction. There can be only 4 right angles which touch each other—they either touch with their points and form a cross or, by the touching of their diverging sides, they form right-angle planes—in most instances creating the square.

The horizontal-vertical cross consists of one warm and one cold line—it is nothing other than the central position of the horizontal and vertical. This accounts for the cold-warm or warm-cold temperature of the right angle, depending upon its direction. Details concerning this will be given in the section entitled "Basic Plane."

**Lengths**    The further difference between the simple angular lines consists in the lengths of the individual sections—a circumstance which greatly modifies the basic sound of these forms.

**Absolute Sound**    The **absolute sound** of the given forms depends upon three conditions, and changes as follows to:

1. sound of straight lines with above-mentioned changes (Fig. **25**),
2. sound of the inclination to a more or less acute tension (Fig. **26**), and
3. sound of the inclination to a smaller or greater conquest of the plane (Fig. **27**).

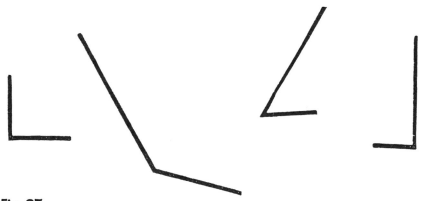

Fig. **25**
Examples of angular lines.

Fig. **26**

Fig. **27**

These three sounds can create a **triple sound.** They can also, on the other hand, be used singly or in pairs—a matter which depends upon the construction as a whole. All three sounds cannot be entirely eliminated, but one or the other can out-sound the rest to such an extent that they can scarcely be heard.

The most objective of the three typical angles is the right angle, which also is the coldest. It divides the square plane into exactly 4 parts.

The acute angle is the tensest as well as the warmest. It cuts the plane into exactly 8 parts.

Increasing the right angle leads to the weakening of the forward tension and the desire for the conquest of the plane grows in proportion. This

**Triple
Sound**

**71**

greed is, nevertheless, restrained in so far as the obtuse angle is not capable of dividing the plane exactly: it goes into it twice and leaves a portion of 90° unconquered.

**Three Sounds**

The three different sounds of these three forms thereby correspond:

1. the cold and controlled,
2. the sharp and highly active, and
3. the clumsy, weak and passive.

These three sounds and, therefore, these three angles, give a fine graphic translation of the artistic process:

1. the sharp and highly active in the inner thought (vision),
2. the cool and controlled in masterly execution (realization), and
3. the unsatisfied feeling and the sensation of one's own weakness following the completed work (in the case of artists, called "hangover").

**Angular Lines and Colour**

We spoke above of 4 right angles which form a square. The relationships with the pictorial elements can only be briefly discussed here, but still the parallels of angular lines with colours must be indicated. The cold-warm of the square and its definite plane-like nature, immediately become signposts pointing to **red**, which represents a midway point between yellow and blue and carries within it cold-warm characteristics.[1] Not without reason has the red square appeared so often of late. It is not, therefore, completely without justification that the **right angle** is placed on a parallel with **red**.

Under class d) of angular lines, it is necessary to emphasize a special angle which lies between the right and acute angles—an angle of 60° (right angle − 30° and acute + 15°). When the openings of two such angles are brought together, they produce an equilateral triangle—three

---

[1] See "On the Spiritual in Art," p. 67, Figure II. Also, Table V in "Basic Elements" in the Bauhaus Book, Bauhaus Verlag, 1923.

sharp, active angles—and become the sign-post to yellow.[1] Thus, the **acute angle** has a **yellow** colour within.

The obtuse angle increasingly loses its aggression, its piercing quality, its warmth, and is, thereby, distantly related to a line without angles which, as will be shown below, constitutes the third primary, typical form of the plane—the circle. The passiveness in the **obtuse angle**, the almost missing forward tension, gives this angle a light **blue** tone.

In addition, further relationships can be indicated: the acuter the angle, the closer it approaches sharp warmth and vice versa, the warmth decreases toward the red right angle and inclines more and more to coldness, until the obtuse (150°) angle develops; this is a typical blue angle and is a presentiment of the curved line which, in its further course, has the circle as its final goal.

This process can be given the following graphic expression:

Fig. **28**
System of typical angles ⇄ colours.

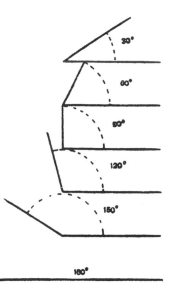

Fig. **29**
Angle measurements.

1 Ibidem.

Thus it follows:

AV  B  BV  . . . yellow,
AIV  B  BIV  . . . orange.    Acute angle.

AIII  B  BIII  . . . red.     Right angle.

AII  B  BII  . . . violet,
AI  B  BI  . . . blue.        Obtuse angle.

The next jump of 30° is the transition from angular lines to straight lines:

A  B  C  . . . . black.     Horizontal.

Since, however, the typical angles in their continued development can form planes, the further relationships between line-plane-colour arise automatically. We may therefore make the following **diagrammatic indication of the line-plane-colour relationships:**

**Plane and Colour** | **Angular Lines:** | **Primary Forms:** | **Primary Colours:**

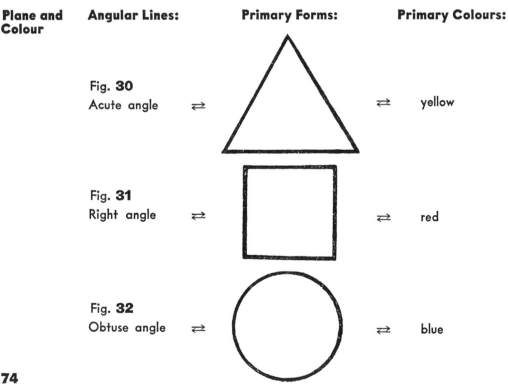

Fig. **30**
Acute angle  ⇄          ⇄  yellow

Fig. **31**
Right  angle  ⇄          ⇄  red

Fig. **32**
Obtuse angle  ⇄          ⇄  blue

If the parallels just made are correct, the following conclusions may be drawn from a comparison of the two: the sounds and characteristics of the components produce, in certain cases, a sum of characteristics which are not covered in the first group. Similar facts are not unknown to other sciences, e.g., chemistry: the sum divided into its components in many cases fails to be restored in the combination of the components.[1] Perhaps, in such cases, one is confronted with an unknown law, whose vague appearance seems deceptive.

For example:

| Line | Colour | | in respect to temperature and light | Line and Colour |
|------|--------|---|-------------------------------------|-----------------|
| Horizontal | black | = | blue | |
| Vertical | white | = | yellow | |
| Diagonal | grey, green | = | red | |

| Plane | Components | | Sum gives the third primary | Plane and Components |
|-------|-----------|---|-----------------------------|----------------------|
| Triangle | horizontal black = blue | diagonal red | yellow | |
| Square | horizontal black = blue | vertical white = yellow | red | |
| Circle[2] | **Tensions** (as components) active = yellow passive = red | | blue | |

---

[1] In chemistry, the equality sign is not used in such cases, but rather, a ⇄, which points to relationships. My task is to point out "organic" relationships between the elements of painting. Even in cases where it is impossible to establish identities, that is, to prove them conclusively, I will indicate their inner relationship by the use of two arrows ⇄. Furthermore, one must not in such cases be deterred by possible mistakes: the truth is not infrequently reached by way of error.

[2] The origin of the circle will be described in the analysis of curved lines—attack and yielding resistance.
The circle is, at all events, a special case among the three primary forms—straight lines are unable to create it.

Thus, the sum would supply the missing factor necessary to balance. In this way, the components would be derived from the sum—lines from the plane —and vice versa. Artistic practice supports this professed rule in so far as black-white painting—consisting of lines and points—acquires a more pronounced balance by the addition of a plane (or planes, as the case may be): lighter weights require the heavier. This need is evident to a still greater degree in colour painting, a fact well known to every painter.

**Method**

My aim in considerations of this sort extends beyond the attempt to establish more or less accurate rules. It appears to me to be almost as important to stimulate discussion about theoretic methods. The methods of art analysis have been, until now, far too haphazard and, frequently, too personal in nature. The coming period demands a more exact and objective way to make collective work in the science of art possible. Preferences and talents remain different here as well as elsewhere, and the work accomplished by each person can be only in accordance with his powers. For this very reason, a work program accepted by many is of especial importance. Here and there arises the idea of art institutes work-

**Inter-national Art Institutes**

ing in a systematic way—an idea which will surely soon be realized in various countries. It can be maintained altogether without exaggeration, that a science of art erected on a broad foundation must be interna-tional in character: it is interesting, but certainly not sufficient, to create an exclusively European art theory. Geographic and other external con-ditions are not the important ones in this connection (at least not the only ones) but, rather, it is the differences in inner content of the "nations"— particularly in the field of art—which are, in the first instance, the deciding factor. A sufficient example of this is our black mourning and the white mourning of the Chinese.[1] There can be no greater contrast in feeling for

---

[1] Those differences which require exact examination, not alone in reference to "nation" but also to race, will surely be determined with no particular difficulty if the investi-gation is carried on exactly and systematically. Nevertheless, in matters of detail, which not infrequently acquire unexpected importance, it will often be impossible to remove insuperable obstacles—influences which often, in the beginning of a culture, affect details and lead in some cases to superficial imitations and thereby becloud further development. On the other hand, purely external phenomena receive little attention

colour—"black and white" is quite as customary with us as "heaven and earth." Yet out of this, a deep-lying, and consequently not immediately recognizable, relationship of the two colours can be discovered: both are silence. This example, therefore, perhaps sheds an especially strong light upon the difference between the inner nature of Chinese and Europeans. After thousands of years of Christianity, we Christians experience death as a final silence, or, according to my characterization, as a "bottomless pit," whereas the heathen Chinese look upon silence as a first step to the new language, or, in my way of putting it, as "birth."[1]

The "national" is a "question" which today is either underestimated or treated only from an external and superficial-economic standpoint; for this reason, its negative side comes strongly to the fore and covers up the other side completely. It is this very other side, that is, the inner, which is essential. From this last standpoint, the sum of the nations would form not a dissonance but rather, harmony. Presumably, art would also intervene in this seemingly hopeless case—this time in a scientific way—unconsciously or involuntarily, with harmonizing effect. The realization of the idea of organizing an international art institute can become an introduction to this.

**I B 2.** The simplest forms of angular lines can become complex when other lines join the two original ones. In this case, the point receives not two but, rather, several pushes which (for simplicity's sake) are derived from two, not several, alternating forces. The schematic type of these lines of many angles is composed of several segments of equal length which stand at right angles to each other. Accordingly, the endless series of many-angled lines becomes modified in two directions:

**Complex Angular Lines**

---

in a systematic work and can in this kind of theoretic work be neglected which, naturally, would not be possible in the case of an exclusively "positivistic" approach. Even in these "simple" cases, a one-sided approach can lead only to one-sided conclusions. It would be short-sighted to assume that a people is "accidentally" placed in a definite geographic position which determines its further development. It would also be quite as insufficient to assert that the political and economic conditions which, in the final analysis, flow out of this people itself, guide and shape its creative power. The goal of a creative power is an inner one—this inner cannot be shelled out of the external alone.
**1** See "On the Spiritual in Art," p. 68.

1. through combinations of acute, right, obtuse and free angles, and
2. through various lengths of the segments.

Thus a **many-angled line** can be composed of the most diverse parts—from the simpler to the ever more complex.

Sum of obtuse angles, which have equal segments,
   "    "    "      "     "   have unequal segments,
   "    "    "      "     "   alternate with acute angles and have equal or unequal segments,
   "    "    "      "     "   alternate with right and acute angles, etc. (Fig. **33**).

Fig. **33**
Free many-angled lines.

**Curved Lines**

These lines are also called **zig-zag lines** and when they have equal segments, they form an animated straight line. When acute-angled in form, they suggest height and, thus, the vertical; when obtuse-angled, they tend toward the horizontal. The endless potentiality of straight lines for movement is always retained in the above-mentioned forms.

If, particularly in the case of the formation of the obtuse angle, a force is regularly augmented and the angle increases in size, this form tends toward the plane and, especially, toward the circle. The relationship of the obtuse-angle line, the curved line and the circle is, thereby, not only of an external, but of an inner nature, as well. The passivity of the obtuse angle and its unaggressive attitude toward its surroundings, causes it to cave in more and more until it ends in the profoundest self-absorption of the circle.

**II.** When two forces act upon the point in such a way that one force continually, but always to the same degree, exceeds the other in pressure, a curved line is created whose basic form is

I. **the simple curved line.**

It is really a straight line which has been brought out of its course by constant sideward pressure—the greater was this pressure, the farther went the diversion from the straight line and, in the course of this, the greater became the outward tension and, finally, the tendency to close itself.

The inner difference from the straight line consists in the number and kind of tensions: the straight line has two distinct primitive tensions which play an unimportant role in the case of the curved line, whose chief tension resides in the arc (third tension, which opposes and out-sounds the others) (Fig. **34**). While the piercing quality of the angle disappears, there is still greater force confined here which, even though it is less aggressive, has greater endurance concealed within it. Something thoughtlessly youthful exists in the angle while in the arc is a mature energy, rightfully self-conscious.

This maturity and the elastic full sound of the curved line lead us to seek the contrast to the straight line—not in the angular—but definitely in the curved line: the origin of the curved line and the character proceeding

Fig. **34**

Tensions of straight and curved lines.

**Contrasts
in Lines**

out of this origin, i.e., the complete absence of the straight line, compel us to state that:

**the straight line** and **the curved line** represent **the primary contrasting pair of lines** (Fig. **35**).

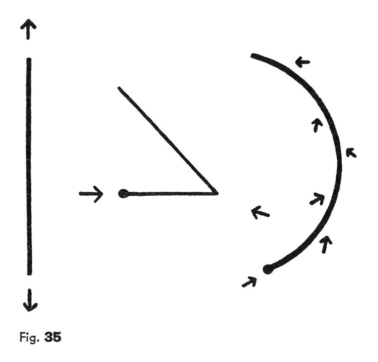

Fig. **35**

The angular line must, therefore, be looked upon as an intermediate element: birth—youth—maturity.

Whereas the straight line is a complete negation of the plane, the curved line carries within it a **seed of the plane.** If the two forces, with the conditions unchanged, roll the point ever farther, the developing curve will sooner or later arrive again at its starting point. Beginning and end flow into each other and in the same instant disappear without a trace. The most unstable and, at the same time, the most stable of planes is created —the circle (Fig. **36**).[1]

Fig. **36**
Developing circle.

Fig. **37**
Developing spiral.

---

[1] A form diverging in a regular manner from the circle is the spiral (Fig. **37**); the force acting from within exceeds the outer in a uniform measure. The spiral is, therefore, a circle going off its track in a uniform manner. Besides this difference, another can be observed which, for painting, is much more significant: the spiral is a line, while the circle is a plane. Geometry does not make this distinction which is exceedingly important for painting; aside from the circle, it designates the ellipse, the figure eight and similar plane forms as lines (curves). The term used here, the "curved line," is not the equivalent of the more exact geometric terminology (parabola, hyperbola, etc.) for geometry, from its standpoint on the basis of formulae, must inevitably make classifications which in this connection are out of the question for painting.

**Contrast in Relation to the Plane**

Even the straight line, in the final analysis, carries within it with its other characteristics the desire (even though deeply hidden) to give birth to a plane; to transform itself into a more compact, more self-contained thing. The straight line is capable of doing this, although, in contrast to the curved line which can create a plane with two forces, it has need of three impulses in plane creation. In the case of this new plane, beginning and end cannot completely disappear, but are observable at three points. Complete absence of the straight and the angular on the one hand and, on the other hand, three straight lines with three angles—these are the signs of the two primary planes which stand in the greatest contrast to each other. Therefore, these two planes confront each other as

Fig. **38**
**the primary contrasting pair of planes.**

**Three Pairs of Elements**

We have now reached the point where it is logical to establish certain relationships between those three parts of the pictorial elements which actually merge with each other, but which are theoretically separable: line—plane—colour.

| Straight line, | triangle, | yellow, |
|---|---|---|
| Curved line. | circle. | blue. |
| **1. Pair** | **2. Pair** | **3. Pair** |

**Three primary contrasting pairs of elements.**

This abstract adherence to law peculiar to one of the arts, finds in this **Other Arts**
art a constant, more or less conscious application, which can be compared
with nature's adherence to law and which in both cases—art and nature
—affords the inner human being a very particular satisfaction. Funda-
mentally, this same abstract, law-abiding quality is most certainly the
property of other art expressions. The spatial elements in sculpture and
architecture,[1] the tonal elements in music, the elements of movement in
the dance, and the word elements[2] in poetry, all have need of a similar
uncovering and a similar elementary comparison with respect to their
external and their inner characteristics, which I call "sounds."

The tables set up in the sense proposed here must be subjected to an
exact examination, and it is easily possible that these individual tables,
in the final analysis, will result in **one** synthetic table.

Emotional assertion surely is originally rooted in intuitive experiences
and compels our taking the first steps along this inviting road. The emo-
tional alone, however, in this case could easily lead off the track; this can
only be avoided with the help of exact analytic work. By the use of the
right[3] method, it is possible, however, to avoid pitfalls.

The progress won through systematic work will create an elementary dic- **Dictionary**
tionary which, in its further development, will lead to a "grammar" and,
finally, to a theory of composition which will pass beyond the boundaries
of the individual art expressions and become applicable to "Art" as a
whole.[4]

---

[1] The identity of the basic elements in sculpture and architecture explains in part the
victorious subjugation of sculpture by architecture today.
[2] The nomenclature used here for the basic elements of the various arts must be looked
upon as provisional. Even the commonly-held concepts are hazy.
[3] This is a clear example of the necessary simultaneous use of intuition and calculation.
[4] See clear suggestions of this in "On the Spiritual in Art" and in my article "Über
Bühnenkomposition" in "Der Blaue Reiter," Piper Verlag, Munich, 1912.

The dictionary of a living language is immutable as it undergoes changes perpetually: words become submerged, die; words are created, come new into the world; foreign words are brought home from across the borders.

Strangely enough, a grammar in art today still seems ominously dangerous to many.

**Planes**
The more alternating forces there are acting on the point, the more diverse their directions, and the more different the individual segments of an angular line are in length, the more complex will be the planes created. The variations are inexhaustible (Fig. **39**).

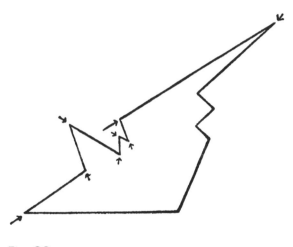

Fig. **39**

This is mentioned here to aid in the clarification of the differences between the angular line and the curve.

The likewise inexhaustible variations in the planes which owe their origin to the curve, never lose a certain—even though distant—relationship with the circle, since they carry circle tensions within them (Fig. **40**).

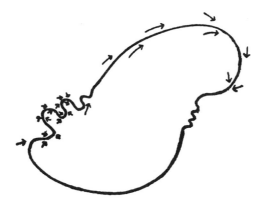

Fig. **40**

Some of the possible variations of the curved line must still be mentioned.

**II 2.** A complex curved or **wave-like** line can consist of:

1. geometric parts of a circle, or
2. free parts, or
3. various combinations of these.

These three types cover all the forms of the curve. Some examples will confirm this rule.

Curve—geometric wave-like:
Equal radius—uniform alternation of positive and negative pressure. Horizontal course with alternating tensions and release (Fig. **41**).

**Wave-like Line**

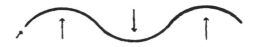

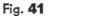

Fig. **41**          **85**

Curve—free wave-like:
Displacement of the above lines with the same horizontal extension:
1. the geometric character disappears,
2. positive and negative pressure with irregular alternation, whereby the former gets much the upper hand of the latter (Fig. **42**).

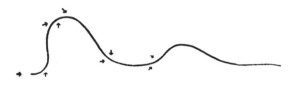

Fig. **42**

Curve—free wave-like:
Displacement increased. Especially temperamental struggle between the two forces. The positive pressure pushes to a very great height (Fig. **43**).

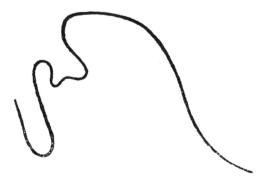

Fig. **43**

Curve—free wave-like:

Variations of these last:

1. the high point directed toward the left—giving way in the face of the energetic attack of the negative pressure,
2. stress on the height through the broadening of the line—accentuation (Fig. **44**).

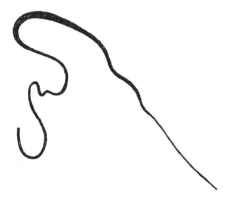

Fig. **44**

Curve—free wave-like:

After the initial ascent toward the left, immediate, definite tension on a large scale upwards and to the right. Relaxing to circular form toward the left. Four waves are subordinated to one direction, from lower left to upper right[1] (Fig. **45**).

---

[1] Further discussion of the sound "right," "left," and its tensions will be found in the section "Basic Plane."

The effects of right and left can be investigated by holding the book in front of the mirror; above and below, by turning the book upside-down.

The "reflection" and the "upside-down" are still rather mysterious facts which are of great importance to the theory of composition.

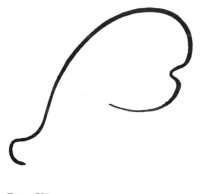

Fig. **45**

Curve—geometric wave-like:
Contrasted to the geometric wave-like line above (Fig. **41**)—pure ascent with modest diversions to the right and left. The sudden weakening of the wave leads to increased vertical tension. Radius from bottom to top— 4, 4, 4, 2, 1 (Fig. **46**).

Fig. **46**

In the examples given, two different kinds of conditions produce the result:

1. the combination of the active and passive pressures,                    **Effects**
2. the contribution of the sound of direction.
Associated with these two sound factors can further be
3. the emphasis in the line itself.

This linear accentuation is a gradual, or a spontaneous, increase or de-          **Emphasis**
crease in strength. A simple example will make detailed explanations
superfluous:

Fig. **48**
The same, with uniformly de-
creasing emphasis whereby
heightened tension of ascent
is attained.

Fig. **47**
Geometric curve in ascent.

Fig. **49**
Spontaneous accentuations of a free curved line.

**Line and Plane**

The spreading out, especially in the case of a short, straight line, bears a relation to the growing point. Here, too, the question "When does the line as such die out, and at what moment is a plane born?", remains without a definite answer. How shall the question "Where does the river stop and the sea begin?", be answered?

The boundaries are indefinite and mobile, Everything here depends upon proportions, as was the case with the point—the absolute is reduced by the relative to an indistinct, subdued sound. In practice, this "approaching-of-the-boundary" is much more precisely expressed than in pure theory.[1] The "approaching-of-the-boundary" is a potent source of expression, a powerful means (in the final analysis, an element) to ends in composition.

This means, in cases of an acute dryness of the main elements in a composition, produces among these elements a certain vibration and causes

90    [1] Several full page diagrams in this book are clear examples of this. (See Appendix.)

a definite loosening-up of the stiff atmosphere of the whole and can, when used to an exaggerated extent, lead to almost repulsive over-niceties. At all events, one is here still completely dependent upon feeling.

A generally accepted distinction between line and plane is, for the present, impossible—a fact which is perhaps bound up with the still little advanced state of painting, as yet of an embryonic nature, if not possibly determined by the very character of this art.[1]

A particular sound factor of the line is
4. the outer edges of the line,
which are formed partly by the just mentioned accentuation. In these cases, both edges of the line are to be considered as independent outer lines, a fact which has more theoretic than practical value.

**Outer Boundaries**

In the question of the outer shape of the line, we are reminded of the same question in the case of the point.

Smooth, jagged, torn, rounded are attributes which in the imagination create certain sensations of touch, due to which the outer borders of a line, from a purely practical point of view, should not be underestimated. With the line, the combination possibilities in the transference to touch sensations are far more many-sided than with the point: for example, smooth edges of a jagged line; jagged edges of a smooth, rounded line; torn edges of a jagged line; torn edges of a rounded line; etc. All of these characteristics can be used in the three types of lines—straight, angular and curved—and each of the two sides can have a special treatment.

---

1 The means to this "approaching-of-the-boundary" extends far beyond the limits of the problem of line-plane and into all the elements of painting and their application; e.g., colour uses this means to a still greater extent, thereby possessing countless possibilities. The basic plane, too, works with this medium which, together with the other means of expression, belongs among the rules and laws of the theory of composition.

**Combined Line**

**III.** The third, and last, basic type of line is the result of the combination of the first two kinds. Consequently, it must be called the **combined line.** The nature of its individual segments determines its particular character:

1. it is a **geometric combined line,** if the parts brought together are exclusively geometric,
2. it is a **mixed combined line,** if free parts are associated with geometric, and
3. it is a **free combined line,** if it is composed entirely of free lines.

**Force**

Quite apart from differences in character which are determined by the inner tensions, and quite apart from their processes of creation, the original source of every line remains the same—the **force.**

**Composition**

The action of the force on the given material brings life into the material, which expresses itself in tensions. The tensions, for their part, permit the inner nature of the element to be expressed. An element is the objective result of the action of the force on the material. The line is the clearest and simplest case of this creative process which always takes place in exact obedience to law and, therefore, allows and requires an exact law-abiding application. Thus, a **composition** is nothing other than an **exact law-abiding organization** of the vital **forces** which, in the form of tensions, are shut up within the elements.

**Number**

In the final analysis, every force finds expression in number; this is called **numerical expression.** In art at present, this remains a rather theoretic contention but, nevertheless, it must not be left out of consideration. We today lack the possibilities of measurement which some day, sooner or later, will be found beyond the Utopian. From this moment on, it will be possible to give every composition its numerical expression, even though this may at first perhaps hold true only of its "basic plan" and its larger

complexes. The balance is chiefly a matter of patience which will accomplish the breaking down of the larger complexes into ever smaller, more subordinate groups. Only after the conquest of numerical expression will an exact theory of composition (at the beginning of which we now stand) be completely realized. Simpler relationships associated with their numerical expression were employed in architecture perhaps as early as thousands of years ago (e.g., in the Temple of Solomon), in music, and to some extent in poetry; while more complex relationships did not find numerical expression. It is very tempting to work with simple numerical proportions which, legitimately, are particularly suited to present day tendencies in art. Nevertheless, after this step has been passed, added complexity in numerical relationships will appear just as tempting (or, perhaps, even more tempting) and will be used.[1]

The interest in numerical expression runs in two directions—the theoretical and the practical. In the first, obedience to law plays the greater role; in the second, utility. Law is subordinated here to purpose whereby the work of art attains the highest quality—genuineness.

Until now, individual lines were classified and tested for their characteristics. The different ways of using several lines and the nature of their reciprocal effect, the subordination of individual lines to a group of lines or to a **complex of lines** is a question of composition and passes beyond the limits of my present purpose. In spite of this, a few more characteristic examples are necessary, to the extent that the nature of the individual line can be illuminated by these examples. Some combinations will be very briefly shown here solely as a suggestion of the way to more complex structures.

**Complexes of Lines**

---

[1] See "On the Spiritual in Art," p. 90.

**Some simple examples of rhythm:**

Fig. **50.** Repetition of a straight line with alternation of weights.

Fig. **51.** Repetition of an angular line.

Fig. **52.** Opposed repetition of an angular line, plane formation.

Fig. **53.** Repetition of a curved line.

Fig. **54.** Opposed repetition of a curved line, repeated plane formation.

Fig. **55.** Central-ryhthmic repetition of a straight line.

Fig. **56.** Central-rhythmic repetition of a curved line.

Fig. **57.** Repetition of an accented curved line by means of an accompanying line.

Fig. **58.** Contrasting repetition of a curved line.

Fig. **50**          Fig. **51**                    Fig. **52**                    Fig. **53**

Fig. **54**                    Fig. **55**                    Fig. **56**

Fig. **57**                                    Fig. **58**

The simplest case is the exact **repetition** of a straight line at equal inter-
vals—the primitive ryhthm (Fig. **59**),
or in uniformly increasing intervals (Fig. **60**),
or in unequal intervals (Fig. **61**).

Fig. **59**                    Fig. **60**                    Fig. **61**

The first kind presents a repetition which has, primarily, **quantitative re-
inforcement** as its purpose as, for example, in music where the sound of
one violin is reinforced by many violins.

In the second kind, an accompaniment of the **qualitative** enters along
with the quantitative reinforcement which, in music, appears about like a     **95**

repetition of the same measures after a somewhat long interruption or, in the case of repetitions in "piano," the movement is qualitatively modified.[1]

The third kind, in which a more complex rhythm is used, is the most intricate.

Considerably more complicated combinations are possible in the case of angular lines and, especially, in that of curved lines.

Fig. **62**
Contrasting combination of a curved line with an angular line. The characteristics of both acquire a strengthened sound.

Fig. **63**
Curved lines running along with each other.

1 Repetition by other instruments of the same pitch must be viewed as a coloured-qualitative one.

Fig. **64**
Running apart.

Quantitative and qualitative intensifications are present in both instances (Figs. **63** and **64**); nevertheless, they carry within them something soft and velvet-like and due to this, the lyric oversounds the dramatic. In the case of an opposite arrangement of lines, the contrast cannot attain its full sound.

Such really independent complexes can, of course, be subordinated to still greater ones, and these greater ones, in turn, form only a part of the total composition—in about the same way that our solar system forms only a part of the cosmic whole.

The universal harmony of a **composition** can, therefore, consist of a number of complexes rising to the highest point of contrast. These contrasts can even be of an inharmonious character, and still their proper use will not have a negative effect on the total harmony but, rather, a positive one, and will raise the work of art to a thing of the greatest harmony.

**Compo-
sition**

**Time**     The element of time, in general, is discernable in the line to a much greater extent than it was in the case of the point: length is a concept of time. On the other hand, the time required to follow a straight line is different from that required for a curved one, even though the lengths are the same; the more animated the curved line becomes, the longer is the span of time it represents. Thus, the possibilities of using line as a time element are manifold. The application of time has a different inner colouration in horizontal and vertical lines, even if of equal lengths, and perhaps it is in reality a matter of different lengths which, at any rate, would be psychologically explainable. The time element in a purely linear composition must not, therefore, be overlooked and in the theory of composition it must be subjected to an exact examination.

**Other Arts**     As with the point, the line can be used in forms of art expression other than painting. Its nature finds a more or less precise translation in the means of other arts.

**Music**     What a **musical line** is, is well known (see Fig. **11**).[1] Most musical instruments are of a linear character. The pitch of the various instruments corresponds to the width of the line: a very fine line represents the sound produced by the violin, flute, piccolo; a somewhat thicker line represents the tone of the viola, clarinet; and the lines become more broad via the deep-toned instruments, finally culminating in the broadest line representing the deepest tones produced by the bass-viol or the tuba.

Aside from its width, the line is produced in its colour variations by the diversified chromatic character of different instruments.

The organ is quite as typical a "linear" instrument as the piano is a "point" instrument.

**98**     ───────────────────────────────────────

1 The line grows organically out of points.

It can be asserted that in music the line supplies the greatest means of expression. It manifests itself here in time and space just as it does in painting.[1] How time and space are related to each other in the two forms of art is a question by itself which, with its distinctions, has led to an exaggerated scrupulousness and, thereby, the concepts of time-space or space-time have been differentiated far too much.

The degrees of intensity from pianissimo to fortissimo can be expressed in an increasing or decreasing sharpness of the line, that is, in its degree of brilliance. The pressure of the hand on the bow corresponds exactly to the pressure of the hand on the pencil.

It is particularly interesting and significant that the graphic musical representation in common use today—musical notation—is nothing other than various combinations of point and line. The time is recognizable therein only by means of the colour of the point (white and black only, which consequently leads to the restriction of the means) and the number of pennant stripes (lines). The pitch is likewise measured in lines, and five horizontals form the basis of this. The unqualified brevity and the simplicity of the means of translation, which in clear language convey the most complex sound phenomena to the experienced eye (indirectly to the ear) are instructive. Both of these characteristics are very alluring for the other forms of art and it is understandable that painting or the dance should be in search of its own "notes." There is, however, only one way to arrive finally at their own graphic expression—analytic separation into fundamental elements.[2]

---

[1] In measuring tonal pitch in physics, special apparatus is used which projects the vibrating tone mechanically on a surface and which thereby gives the musical tone a precise graphic form. Similar things are also done with colour.
In many important cases, the science of art already makes use of exact graphic translations as material for the synthetic method.
[2] The relationships of the pictorial means to the means of other art expressions and, finally, to the phenomena of other "worlds," can be indicated only very superficially here. "Translations," especially, and their possibilities—in general, the transcription of various phenomena into their respective linear ("graphic") and colour ("pictorial") forms—require a thorough study of linear and colour expression. There is no question that, in principle, every phenomenon of every world admits of such expression—the expression of its inner nature—regardless of whether it be Raphael, J. S. Bach, a storm,

**The Dance**    In the **dance**, the whole body—and in the new dance, every finger—draws lines with very clear expression. The "modern" dancer moves about the stage on exact lines, which he introduces in the composition of his dance as a significant element (Sacharoff). The entire body of the dancer, right down to his finger tips, is at every moment an uninterrupted composition of lines (Palucca). The use of lines is, indeed, a new achievement but, of course, is no invention of the "modern" dance: apart from the classic ballet, every people at every stage of their "evolution" work with line in the dance.

**Sculpture**    One is not at a loss for proof of the role and significance of the line in
**Architecture**    **sculpture** and **architecture**—the structure in space is, at the same time, a linear construction.

An exceedingly important task of art-scientific research would be an analysis of the fate of lines in architecture, at least in the case of the typical works of various peoples in various epochs, and, what is bound up with this, a purely graphic translation of these works. The philosophic basis of this work would be the determination of the relationships of graphic formulae to the spiritual atmosphere of the given time. The final topic, for the present, would be the logically necessary restriction to the horizontal-vertical, with the conquest of the air by the projecting upper parts of a building, for which present day building materials and present day building techniques offer extensive and reliable possibilities. The principle of building just described must, to follow my terminology, be designated as cold-warm or warm-cold, depending upon whether the horizontal or the vertical is emphasized. This principle has in a short time produced a number of important works, and they continue to be created in the most diverse countries (Germany, France, Holland, Russia, America, etc.).

---

fear, a cosmic process, tooth-ache, a "high" or a "low" phenomenon, a "high" or a "low" experience. The only danger would be to remain bound to the external form and to neglect the content.

The rhythmic form of the **verse** finds its expression in the straight and the curved line, where a regular recurrence is exactly denoted graphically—meter. Besides this rhythmic measurement of length, which is precise, the verse develops on recital a certain musical melodic line which gives expression, in an inconstant and variable form, to the rise and fall, the tension and the release of tension. Fundamentally, this line is law-abiding as it is bound up with the literary content of the verse—the tension and release of tension are analagous to content. The variability resulting from a departure from the law-abiding line depends in the same way, and with greater freedom, upon the person reciting; similarly, in music, the variation in the intensity of the sound (forte and piano) is dependent upon the musician. This imprecision in the musical melodic line is less dangerous in "literary" verse. It is fatal in an abstract poem because the line of pitch values represents an essential, definite element. A notation should be found for this kind of poetry which would show the pitch line as exactly as notation does in music. The question of the possibility and limits of abstract poetry is complicated. It must only be mentioned here that abstract art must reckon with a more precise form than representative art, and that the pure question of form is in the first case essential and in the second, very often immaterial. I have discussed this same difference in relation to the use of the point. As has already been said above, the point is—silence.

In a neighboring field of art—**engineering art** and the technics closely related to it—the line grows ever more in importance (Figs. **65** and **67**).

So far as I know, the Eiffel Tower in Paris was the most significant early attempt to create an especially high building out of lines; the line has here replaced the plane.[1]

---

[1] A special and very important case in technics is the use of line as the graphic expression of number. The automatic drawing of lines (like that also used in meteorological observations) is a precise graphic representation of an increasing or decreasing force. This representation makes possible the reduction of the use of number to a

Fig. **65**

Diagram of a sailing vessel. Linear construction for the purpose of movement. (Ship's hull and rigging.)

minimum—the line partially replaces the number. The resulting diagrams are clear and also comprehensible to the layman (Fig. **66**).

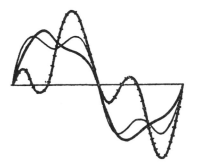

The same method, that of giving expression to a development or a temporary condition by the height of lines, has for years been used in statistics where the charts (diagrams) have to be made by hand and are the result of tedious, pedantically executed work. The method is also used in other sciences (e.g. in astronomy, "lightcurve").

Fig. **66**

Rectification of the curve of an electrical current in graphic representation—by Felix Auerbach, Verlag Teubner.

Fig. **67**
Framework of a motor freightship.

Fig. **68**
Radio tower, seen from below. (Photo Moholy-Nagy.)

Fig. **69**
Forest of masts.

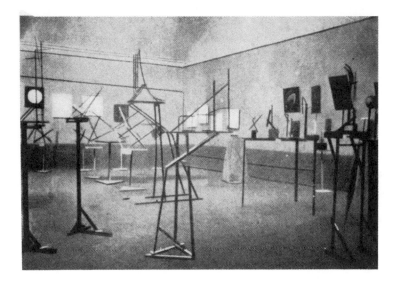

Fig. **70**
A room of the Constructivist Exhibition in Moscow, 1921.

The connections and rivets are points in these linear constructions. These are line-point constructions, not upon the plane, but in space (Fig. **68**).[1]

The **"constructivist"** works of recent years are for the most part and especially in their original form, "pure" or abstract constructions in space, without practical-useful application, which distinguishes these works from the art of the engineer and compels us to assign them to the field of absolute art. The vigorous use and strong accentuation of the line by point connections are striking in these works (Fig. **70**).

<div style="text-align:right"><b>Construc-<br>tivism</b></div>

The use of line in **nature** is an exceedingly frequent one. This subject, which merits special investigation, could be mastered only by a synthe- sizing natural scientist. It would be especially important for the artist to see how nature uses the basic elements in her independent realm; which elements are to be considered; what characteristics they possess; and in which manner they combine to form structures. Natural laws of composi- tion do not reveal to the artist the possibility of superficial imitation (which he frequently sees as the main purpose of the laws of nature) but, rather, the possibility of contrasting these laws with those of art. Also in this point, decisive for the abstract in art, we already discover the law of setting side-by-side or setting opposite (the two principles—the principle of the parallel and the principle of contrast) which was shown in the case of line groupings. The laws of the two great realms—art and nature— separated in this way and living independently, will finally lead to the understanding of the whole body of the laws of world composition and clarify the independent activity of each toward a higher synthetic order: external + inner.

<div style="text-align:right"><b>Nature</b></div>

This viewpoint has, until now, become evident only in **abstract** art which has recognized its rights and duties, and which no longer leans upon the

---

**1** A special technical construction—masts, which are erected for distant transmission of electrical power, affords an instructive example of this (Fig. **69**). One gets the im- pression here of a "technical forest," which looks similar to a "natural forest" of palms or fir trees, pressed flat. In the graphic construction of such a mast, the two basic graphic elements—line and point—are used exclusively.

external shell of natural phenomena. It should not be replied here that this external shell in "objective" art is put to the service of inner purposes —it remains impossible to incorporate completely the inner of one realm into the outer of another.

The line appears in nature in countless phenomena: in the mineral, plant and animal worlds. The schematic construction of the crystal (Fig. 71) is a purely linear formation (an example in plane form—the ice crystal).

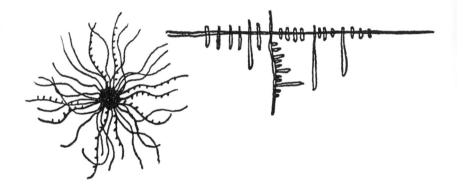

Fig. **71**
"Trichites"—hair-like crystals.                    "Crystal skeleton."
(Dr. O. Lehmann, "Die neue Welt d. flüssigen Kristalle," Leipzig, 1911, pp. 54, 69.)

A plant in its entire development from seed to root (downwards), as far as the beginning of the bud (upwards),[1] passes over from point to line (Fig.

---

[1] The attachment of the leaves around the shoot takes place in the most exact manner, which can be expressed with a mathematic formula—numerical expression—and science has represented this with a spiral-like diagram (Fig. **72**). Compare this with the geometric spiral on p. 81, Fig. **37**.

73) and, as it progresses, leads to more complicated complexes of lines, to independent linear structures, like the network of the leaf or the eccentric construction of evergreen trees (Fig. **75**).

The organic linear pattern of the branches always emanates from the same basic principle but exhibits the most varied arrangements (e.g., among

**105**

trees alone: fir, fig, date palm, or the most bewildering complexes of the liana and various other snake-like plants). Some complexes are, moreover, of a clear, exact, geometric nature and vividly recall geometric constructions made by animals, as, for example, the surprising formation of the spider's web. On the other hand, some are of a "free" nature and made up of free lines; the loose structure reveals no exact geometric construction. Nevertheless, the fixed and exact are not excluded here but are only employed in a different manner (Fig. **74**). Both types of construction are found in abstract painting.[1]

**Geometric and Loose Structure**

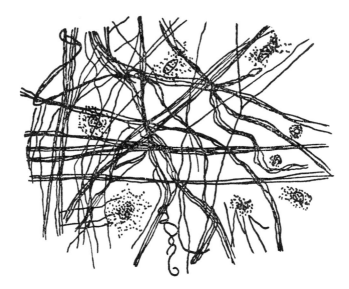

Fig. **74**

"Loose" ligament tissue of the rat.

(K. d. G., Part III, Section IV, p. 75.)

[1] There are two reasons for the fact that in recent years exact geometric construction in painting has seemed so very important to painters: 1, the necessary and natural use of abstract colour in the "suddenly" awakened architecture, where the colour plays a role subordinated to the whole and for which "pure" painting prepared itself unconsciously in "horizontal-vertical" and 2, the necessity which sprang up naturally, dragging

Fig. **75**

Blossom of the Clematis. (Photo Katt Both, Bauhaus.)

Fig. **76**
Line formation of a stroke of lightning.

This relationship, one may well say "identity," is a momentous example of the connection between art laws and natural laws. One must not, however, draw false conclusions from similar cases: the difference between art and nature lies not in the basic laws but, rather, in the material which is subject to these laws. Furthermore, the basic characteristics of the material, which in each case are different, must not be left out of consideration: the proto-element of nature—cell—which is well known today, is in constant, actual movement, whereas the proto-element of painting—point—knows no movement and is rest.

The skeletons of various animals exhibit the most diverse linear constructions in their evolution to the highest form known today—Man. These variations leave nothing to be desired in "beauty" and astonish us time and again by their multiplicity. What surprises us most in this is the fact that these leaps—from the giraffe to the toad, from the human being to the fish, from the elephant to the mouse—are nothing more than variations on **one** theme, and that the most infinite possibilities are drawn entirely out of the **one** principle of concentric structure. The creative power must adhere in this to definite natural laws, which exclude the eccentric. Natural laws of this kind are not intended for art and the road of the eccentric remains completely free and open.

**Thematic Structure**

The finger grows out of the hand exactly as a twig has to grow out of the branch—according to the principle of gradual development out of the

**Art and Nature**

---

painting along with it, to reach back to the elementary, and to seek this elementary not alone in itself, but in its structure as well. This tendency can be observed in the whole attitude of the "new" individual, not only in art but more or less in all fields, as a transition from the primary to the complex, which will sooner or later definitely be accomplished. Abstract art, which has gained its freedom, is also subject here to the "laws of nature" and is forced to proceed as nature did formerly; from a modest beginning with protoplasm and cells, it very gradually advanced to more complex organisms. Abstract art today is also creating primary, or more or less primary, art organisms, whose further development the present day painter can only surmise in its indefinite outlines; these lure him, excite him, but also quiet him when he looks into the perspective of the future which lies before him. It may, for example, be remarked here that those who question the future of abstract art, reckon with the evolutionary state of the amphibians, which are very considerably removed from developed vertebrates, and do not represent the end result of creation but, rather, the "beginning."

**107**

center (Fig. **77**). In painting, a line can exist without subordinating itself externally to the whole, without having an **external relationship** to the center—the subordination here is of an **inner nature**. Even this simple fact must not be underrated in the analysis of the relationships between art and nature.[1]

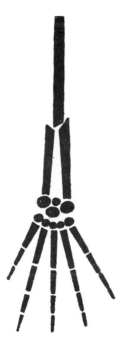

Fig. **77**
Diagram of one of the extremities of a vertebrate.
Termination of the central structure.

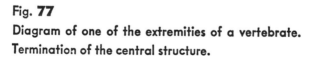

[1] These exceedingly important questions can only be briefly touched upon within the limited confines of this book: they are part of the theory of composition. It must only be emphasized here that the elements are the same in different creative fields and that the differences first reveal themselves in the structure. Furthermore, the examples used here should be looked upon only in this light.

The fundamental difference lies in the purpose or, more exactly stated, in the means to the end and, in the final analysis, the end in art and in nature must—for human purposes—be the same. At any rate, it is advisable in either case not to confuse the shell with the nut.

As for the means, art and nature, in relation to the human being, move in different directions which are far removed from each other, even though they tend toward **one** point. This difference should become fully clear.

Each kind of line seeks the appropriate external means to enable it to attain the shape necessary at the moment and, specifically, on the general basis of economy: the minimum effort for the maximum result.

The material characteristics of the **"graphics"** discussed in the section about the point can apply equally as well to the line, which is the first natural sequel to the point: most easily produced in etching (especially with acid) by deeply embedding the line; careful and difficult work in the woodcut; light lying-on-the-surface in lithography.

**The Graphics**

It is interesting at this point to make some observations about these three techniques and about their relative popularity.

The order is:
1. woodcut—plane, as easiest result,
2. etching—point and line,
3. lithography—point, line, plane.

The artistic interest in the elements and their respective techniques is about in this order.

**109**

**The Woodcut**

I. After a long extended period of interest in brush painting and following the underestimation—in many cases, contempt—for the graphic means which was bound up with this, esteem for the forgotten (especially the German) **woodcut** suddenly awakened. In the beginning, the woodcut was practised on the side as a lower form of art until it spread farther and more victoriously and, finally, became the characteristic type of work of the German graphic artist. In addition to other factors, this circumstance is closely bound up with the plane, to which much attention was paid at that time—plane period of art or the art of the plane. The plane, the chief means of expression of painting at that time, soon thereafter conquered sculpture which became plane sculpture. Today it is clear that this stage of development, reached about 30 years ago in painting and almost simultaneously in sculpture, was directed unconsciously toward architecture. Hence the already mentioned "sudden" awakening of architecture.[1]

**Line in Painting**

It was a matter of course that painting should concern itself again with its other chief medium—the line. This took place (and continues to take place) in the shape of a normal development of the means of expression, an evolution proceeding quietly, which was first looked upon as a revolution and is still viewed as such by many theorists, especially in the case of the use of the **abstract** line in painting. To the extent that abstract art is recognized at all by these theorists, the use of the line in graphics is judged favorably but, in painting, they consider its use to be contrary to its nature and, therefore, forbidden. This is a characteristic example of the existing confusion in concepts: that which can easily be segregated and placed in separate categories is mixed together (art, nature), and, on the other hand, the things that belong together (painting and the graphics) are carefully separated from each other. The line is considered here to be a "graphic" element and not to be used for "pictorial" purposes, although an elementary difference between "the graphics" and "painting" cannot be found and could never be established by the theorists mentioned.

---

[1] An example of the fruitful influence of painting on the other forms of art expression. An elaboration of this subject would surely lead to surprising discoveries in the history of the development of all the art forms.

**2. Etching**, of all existing techniques, is able to create most precisely the line lying firmly in the material and, more especially, the very thin line. It was, therefore, brought out of the old storage chest and the search which began for elementary forms was bound to lead to the thinnest line, which, viewed in the abstract, is an "absolute" sound among lines.

This same preoccupation with the primary resulted in one other consequence—the most exclusive use of one half of the total form along with the elimination of the other half.[1] In etching particularly, in view of the difficulties encountered in the use of colour, the restriction to the pure, graphic form is especially natural, and for this reason etching is a specifically black and white technique.

**3. Lithography**—as the last invention in the series of graphic processes— affords the highest degree of flexibility and elasticity in its workmanship.

Its particular speed in creation, combined with an almost indestructible hardness of the block, completely suits the "spirit of our time." Point, line, plane, black and white, coloured works—everything is accomplished with the greatest economy. Flexibility in the handling of the lithographic stone: that is, ease of application with any tool, and the almost limitless possibilities of correction—especially the removal of faulty spots which neither the woodcut nor the etching readily permits—and the resulting facility in the execution of works without an exact previously formed plan (e.g., in experiments), fulfill both the external and the inner current need to the highest degree.

Finally, consistently following the road to the primary elements, the particular characteristics of the point also had to be found and illuminated

---

[1] E.g., the exclusion of colour or, at least, its reduction to the minimum sound in any number of cubist works.

**111**

as a part of the purpose of this book. Here, as well, lithography offers its rich means for use.[1]

Point—rest. Line—inwardly animated tension created by movement. The two elements—their intermingling and their combinations develop their own "language" which cannot be attained with words. The exclusion of "trimmings," which hush and obscure the inner sound of this message, lends the greatest brevity and precision to pictorial expressions. The pure form places itself at the disposal of the living content.

---

[1] It remains to be mentioned that the three techniques have a social value and are related to social forms. The etching is certainly of an aristocratic nature: a plate can produce only a few good prints and they, furthermore, turn out differently each time so that every print is unique. The woodcut is more abundant and uniform, but it can be used for colour only with difficulty. The lithograph, on the other hand, is able to yield an almost limitless number of prints with the greatest rapidity in a purely mechanical way and, through the ever more developing use of colour, approaches the hand-painted picture. At any rate, it produces a certain substitute for the picture. The democratic nature of lithography is hereby clearly indicated.

# BASIC PLANE

The term "Basic Plane" is understood to mean the material plane which is called upon to receive the content of the work of art.

It will be designated here by BP.

The schematic BP is bounded by 2 horizontal and 2 vertical lines, and is thereby set off as an individual thing in the realm of its surroundings.

After the horizontal and the vertical have been characterized, the basic sound of the BP must of itself become clear: two elements of cold rest and two elements of warm rest give two double sounds of rest, which determine the tranquil=objective sound of the BP.

When the one or the other pair predominates, either in the width or height of the BP, this preponderance determines in any particular case the predominance of the cold or the warm in the objective sound. Thus, from the start, the individual elements are brought into a colder or warmer atmosphere, and later on this condition cannot be completely eliminated due to the greater number of opposing elements—a fact which should never be forgotten. This fact, of course, offers many possibilities in composition. For example, a concentration of active tensions tending upwards upon a colder BP (horizontal format) will always more or less "dramatize" these tensions, since the restraining effect here is a particularly strong one. Such restraining influences, when driven to the extreme, can lead to painful, and, indeed, unbearable sensations.

The most objective form of the typical BP is the **square**—both pairs of boundary lines possess an equally strong sound. Coldness and warmth are relatively balanced.

A combination of this most objective BP with a single element which also carries in it the greatest objectivity has, as a result, a coldness similar to death: it can serve as the symbol of death. It is not without reason that our particular time has produced such examples.

But a "completely" objective combination of a "completely" objective

**Concept**

**Pairs of Lines**

**The Square**

**115**

element with a "completely" objective BP should only be looked upon as a relative matter. Absolute objectivity cannot be attained.

**Nature of the BP**

A fact which is of immeasurable importance and which must be viewed as something independent of the powers of the artist is the dependence of all this not only upon the nature of the individual elements, but upon the **nature of the BP** itself.

On the other hand, this fact is a source of great possibilities in composition—a means to an end.

The following simple given facts lie at the bottom of this.

**Sounds**

Every typical BP produced by 2 horizontal and 2 vertical lines has, correspondingly, 4 sides. Each of these 4 sides develops a sound peculiar to it alone, which passes beyond the boundaries of warm and cold rest. A second sound is, therefore, associated each time with the sound of warm or cold rest, which sound is unalterably and organically bound up with the position of the line = boundary.

The position of the two horizontal lines is **above** and **below**.
The position of the two vertical lines is **right** and **left**.

**Above and Below**

That every living thing stands in a fixed relationship to "above" and "below" and must without question remain that way, is a fact true also of the BP which, as such, is also a living thing. This can be partly explained as association or as transference of one's own observations to the BP. We must assume without question, however, that this fact has deeper roots and that the BP is a living being. For a person who is not an artist, this assertion may appear strange. We must, nevertheless, definitely assume that every artist feels—even though unconsciously—the "breathing" of the still untouched BP and that he feels—more or less consciously—a responsibility toward this being and is aware of the fact that frivolous abuse of it is akin to murder. The artist "fertilizes" this being and knows how obediently and "joyfully" the BP receives the right elements in the right order. This somewhat primitive and yet living organism is transformed by the right

116

treatment into a new living organism, which is no longer primitive but which reveals, on the contrary, all of the characteristics of a fully developed organism.

The **"above"** gives the impression of a great looseness, a feeling of lightness, of emancipation and, finally, of freedom. Each one of these related characteristics gives off an accompanying sound, which has in each case a slightly different colour.

This "looseness" is a negation of density. The nearer to the upper border of the BP the smallest individual areas seem to be, the more disintegrated they appear.

The "lightness" leads to further enhancement of this inner quality—the smallest individual areas are not only farther removed from each other, but they themselves lose weight and, thereby, lose still more the capacity to support. Every weightier form thereby grows heavier in this upper position of the BP. The note of heaviness takes on a stronger sound.

"Freedom" produces the impression of a rather light "movement,"[1] and the tension here can more easily play itself out. "Climbing" or "falling" gains in intensity. **Restraint is reduced to a minimum.**

The effect of **"below"** is completely contrary: condensation, heaviness, constraint.

The closer one approaches the lower border of the BP, the denser the atmosphere becomes; the smallest individual areas lie nearer and nearer together and thereby sustain the larger and heavier forms with ever increasing ease. These forms lose weight and the note of heaviness decreases in sound. "Climbing" becomes more difficult—the forms seem to tear themselves loose by main force and something like the grating noise of friction is audible. (A straining upwards and arrested "falling" downwards.) Freedom of movement becomes more and more limited. **The restraint attains its maximum.**

Above

Below

---

1 Ideas like "movement," "climbing," "falling," etc. are derived from the material world. On the pictorial BP they are to be understood as the tensions living within the elements, which are modified by the tensions of the BP.

**117**

These characteristics of the upper and lower horizontal, which together create a double sound of the greatest possible contrast, can be strengthened in a natural way for the purpose of "dramatization," by means of a certain accumulation of heavier forms below and lighter ones above. Thereby the pressure, or, as the case may be, the tension, becomes considerably increased in both directions.

Vice versa, these characteristics can be partially equalized or, at least, modified—and, of course, through the use of the opposite means: heavier forms above, lighter ones below, or, when it is a case of the direction of the tensions, these tensions can be directed from above to below, or from below to above. In this way, a relative balance is also attained.

These possibilities can be represented, purely schematically, as follows:

**Case 1.**—"dramatization"

| | | |
|---|---|---|
| **above** | weight of BP | 2 |
| | weight of forms | 2 |
| | | 4 |

4:8

| | | |
|---|---|---|
| **below** | weight of BP | 4 |
| | weight of forms | 4 |
| | | 8 |

**Case 2.**—"balance"

| | | |
|---|---|---|
| **above** | weight of BP | 2 |
| | weight of forms | 4 |
| | | 6 |

6:6

| | | |
|---|---|---|
| **below** | weight of BP | 4 |
| | weight of forms | 2 |
| | | 6 |

It can be assumed that in time, perhaps, means will be found of accomplishing measurements in the above sense with more or less exactness. At all events, the formula which I have just roughly outlined could be corrected in such a way that the relative nature of "balance" would stand out with clarity. The means of measurement available to us are, however, exceedingly primitive. It is at present almost impossible for us to imagine how, for example, the **weight** of a scarcely visible point could be expressed by an exact number. The reason for this is that the concept "weight" does not represent a material weight but is, rather, the expression of an inner force or, in our case, an inner tension.

The position of the two vertical boundary lines is right and left. The inner sound of these tensions, which are related in our imagination to ascent, is determined by warm rest.

**Right and Left**

Thus, two warm elements, which by their very nature cannot be identical, are associated with the two differently coloured elements of cold rest.

At this point, the following question immediately comes to the fore: which side of the BP is to be considered the right and which the left? The right side of the BP should really be the one which is opposite our left side and vice versa—as is the case with every other living thing. If this were actually so, we could easily project our human characteristics upon the BP, and we would thereby be in a position to define the two sides of the BP in question. With the majority of people, the right side is more developed and, thereby, freer, while the left side is more inhibited and bound.

The contrary is true of the sides of the BP.

The **"left"** of the BP produces the effect of great looseness, a feeling of lightness, of emancipation and, finally, of freedom. Thus, the characterization of "above" is repeated here in every respect. The chief difference lies only in the degree of these characteristics. The "looseness" of "above" unquestionably exhibits a higher degree of loosening up. At the "left" there are more elements of density, but the difference from "below" is, nevertheless, very great. Furthermore, "left" stands behind "above" in

**Left**

lightness, although the weight of "left" in comparison with "below" is much less. The same holds true of emancipation, and "freedom" is more restricted at the "left" than "above."

It is especially important that the degree of these three characteristics varies even in the case of "left," and in such a way that they increase in an upward direction from the center, and diminish downwards in sound. Here, the "left" is, so-to-speak, affected by "above" and "below," and this takes on a special significance for the two angles formed on the one hand by "left" and, on the other, by "above" and "below."

A further parallel to the human being can easily be drawn on the basis of these facts: increasing emancipation from below to above, and on the right side, to be specific.

Therefore, it can be assumed that this parallel is a genuine parallel between two kinds of living things and that the BP must actually be understood to be such a thing and treated accordingly. Since in the course of the work the BP is still completely tied up with the artist and has not yet broken loose from him, its relation to him may be looked upon as a sort of mirrored reflection, which changes the left side to the right side. It is clear that I must adhere to the designation which I have adopted: the BP will not be treated here as a part of the finished work, but solely as the base upon which the work is to be built.[1]

**Right**   Just as the "left" of the BP is inwardly related to "above," the **"right"** in a way is the continuation of "below"—a continuation with the same weakening. Condensation, heaviness and constraint decrease but, nevertheless, the tensions meet with a resistance which is greater, compacter and harder than the resistance of "left."

---

[1] This reaction apparently is later transferred to the finished work, not alone for the artist but for the objective observer as well—in which class the artist, too, must in a way be considered: when, for instance, he takes the position of an objective observer in respect to other artists' works. The view, that that which lies on my right is the "right" may, perhaps, explain the real impossibility of maintaining a completely objective attitude toward the work and of entirely eliminating the subjective.

Just as in the case of the "left," this resistance is divided into two parts—it increases from the center downward and decreases in strength upward. The same influence on the resulting angles—the angles at the upper right and the lower right—is to be noted here as was observed in the case of "left."

Tied in with these two sides is another special feeling which can be explained by the characteristics already described. This feeling has a "literary" aftertaste, which again discloses the very deep-going relationships between the different expressions of art—and which, furthermore, gives us an inkling of the very deep-lying universal roots of all art forms—and, finally, of all spiritual fields. This feeling is the result of the two sole possibilities of movement of the human being, which, in spite of various combinations, actually remain only two.

**Literary**

The one to the "left"—going outside—is movement **into the distance.** In this case the individual leaves his customary surroundings, he frees himself from burdensome conventions which restrain his movements by an almost petrified atmosphere, and he breathes ever more and more freely. He goes on an "adventure." The forms whose tensions are directed to the left therefore contain something "adventurous," and the "movement" of these forms gains more and more in intensity and speed.

**Distance**

The one to the "right"—centered inwardly—is a movement **toward home.** This movement is combined with a certain fatigue, and its goal is rest. The nearer to the "right," the more languid and slow this movement becomes—so that the tensions of the forms moving to the right become ever weaker, and the possibility of movement becomes increasingly limited.

**Home**

If a corresponding "literary" expression for "above" and "below" is needed, one arrives immediately, through association, at the relationship "heaven and earth."

Four boundaries of the BP therefore can be represented as follows:

| Sequence | Tension | "Literary" |
|---|---|---|
| 1. above | toward | heaven, |
| 2. left | into | the distance, |
| 3. right | toward | home, |
| 4. below | toward | the earth. |

One should not imagine that these relationships are to be taken literally, and, above all, should not believe that they can determine the compositional idea. They serve the purpose of representing the inner tensions of the BP analytically, and to bring these tensions into consciousness. This, so far as I know, has not yet been done in a clear way, although it is to be estimated as an important component of the future theory of composition. It can be only briefly remarked here that these organic characteristics of the plane carry over into the realm of space. Here the concept of the space before the individual and the space around the individual—in spite of the inner relationship of the two—would, nevertheless, reveal some differences. This is a subject in itself.

At all events, certain forces of resistance can be felt upon approaching each of the four borders of the BP, and these definitely separate the unit

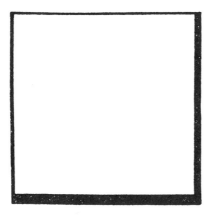

Fig. **77**

Resisting forces of the 4 sides of a square.

BP from the world surrounding it. The approach of a form to the border is, therefore, subject to a special influence, which is of critical importance in the composition. The resisting forces of the borders differ from each other only in the degree of resistance and this, for example, can be represented graphically in the following manner (Fig. **77**).

The forces of resistance can also be translated into tensions and be given graphic expression through displaced angles.

Fig. **78**
External expression of the square, 4 angles of 90° each.

Fig. **79**
Inner expression of the square,
e.g., angles — 60°, 80°, 90°, 130°.

**Relativity**   At the beginning of this section, the square was called the most "objective" form of the BP. Further analysis has clearly shown, however, that even in this case the objectivity may be viewed as nothing other than relative, and that here, too, the "absolute" is unattainable. In other words: only the point, so long as it remains isolated, offers complete "rest." The isolated horizontal or vertical possesses, so to speak, a coloured rest, as warmth and coldness should be regarded as coloured. The square, therefore, cannot be designated as a colourless form.[1]

**Rest**   Of all the forms of the plane, the circle tends most toward colourless rest as it is the result of two forces which always act uniformly and because it lacks the violence of the angle. The point centered in the circle represents the most complete form of rest of the no longer isolated point.

As has already been suggested, the BP presents fundamentally two typical possibilities of carrying elements:

1. the elements lie so materially upon the BP that they give especial emphasis to the sound of the BP, or
2. they are so loosely knit with the BP that the latter's accompaniment is scarcely audible; it disappears, so to speak, and the elements "hover" in space which, however, knows no precise limits (especially in depth).

The discussion of these two cases belongs to the theory of construction and composition. The second case especially—the "destruction" of the BP— can be clearly explained only in connection with the inner characteristics of the individual elements: the recession and advance of the form elements draw the BP forward (toward the observer) and backward in depth (away from the observer) in such a manner that the BP, like an accordion, is pulled apart in both directions. The colour elements possess this power to a high degree.[2]

---

1 Not without reason is the relationship of the square to red so evident: square ⇄ red.
2 See "On the Spiritual in Art."

If a diagonal is drawn through the square BP, this diagonal then stands at an angle of 45° to the horizontal. In the transition of the square BP to other right-angled planes, this angle increases or decreases. The diagonal increases its inclination either to the vertical or the horizontal. It can, therefore, be looked upon as a kind of measure of tension (Fig. **80**).

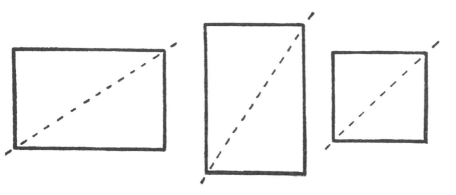

Fig. **80**
Diagonal axis.

This is the origin of the so-called vertical and horizontal formats which, in "objective" painting, have for the most part a purely naturalistic significance and which remain untouched by the inner tension. In painting schools one already came to know the vertical format as a portrait format, and the horizontal format as the format of landscape.[1] These designations had become customary in Paris especially, and were probably transplanted from there to Germany.

It becomes immediately clear that the slightest deviation of the diagonal or of the measure of tension from the vertical or from the horizontal is

**Abstract Art**

[1] The human figure required, naturally, an especially elongated vertical format.

decisive in compositional and, more especially, in abstract art. All the tensions of the individual forms on the BP are given other directions each time, and each time, of course, take on different colours. Drawn upwards, the form complexes also become either compressed or extended. Thus through an unskillful choice of the plane format, a well-conceived order can result in repulsive disorder. Naturally, I mean by "order" not only the mathematical "harmonious structure" in which all of the elements lie in clearly measured directions, but also structure in accordance with the principle of contrast. Elements tending upwards, for example, can be made "dramatic" in the vertical format by bringing them into a milieu of restraint. Let this be mentioned only as a guidepost for the theory of composition.

**Structure**

**Further Tensions**

The point of intersection of the two diagonals determines the center of the BP. A horizontal and, subsequently, a vertical line drawn through this center divide the BP into **four primary parts**, each of which has its specific appearance. The corners of all of these touch at the "indifferent" center, out of which tensions flow diagonally (Fig. **81**).

Fig. **81**

Tensions from the center.

126

The numbers 1, 2, 3, 4 are the resistance forces of the borders.
a, b, c, d are the designations of the four primary parts.

This diagram makes the following consequences possible:

Part a—tension toward 1 2 = loosest combination,
Part d—tension toward 3 4 = greatest resistance.

Parts a and d stand, therefore, in the **greatest contrast** to each other.

Part b—tension toward 1 3 = moderate resistance upwards,
Part c—tension toward 2 4 = moderate resistance downwards.

Parts b and c stand, therefore, in **moderate contrast** to each other, and their relationship can readily be recognized.

In combination with the forces of resistance in the plane's borderlines, a weight pattern results (Fig. **82**).

Fig. **82**
Distribution of weights.

A combination of the two factors is conclusive and answers the question as to which of the two diagonals—bc or ad—should be called the "harmonious" and which the "disharmonious" (Fig. **83**).[1]

1 Compare Fig. **79**—the axis deflected toward the angle at the upper right.

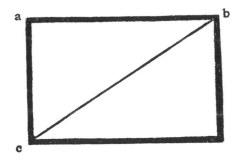

Fig. **83**
"Harmonious" diagonal.

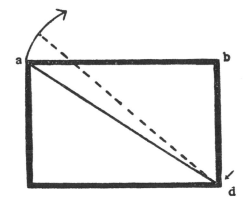

Fig. **84**
"Disharmonious" diagonal.

**Weight**

**128**

The triangle abc rests far more lightly upon the one beneath than the triangle abd which exerts a positive pressure and bears down heavily upon the one under it. This pressure is concentrated especially at the

point d; for this reason, apparently, the diagonal tends to be deflected upwards from the point a and thus compelled to move out of the center. Compared with the mild tension cb, the tension da is of a more complex nature—the purely diagonal direction is accompanied by a diversion upwards. The two diagonals can be designated therefore in still another way:

cb—"lyric" tension,
da—"dramatic" tension.

These denotations, of course, are to be understood only as arrows pointing the way to the inner content. They are bridges from the external to the inner.[1]

**Content**

At all events, it may be repeated: each part of the BP is individual and has its own particular voice and inner colouration.

The analysis of the BP which is employed here is an example of the basic scientific **method** which will play a part in the building up of the new science of art. (This is its theoretic value.) The simple examples which follow point the way to the practical application.

**Method**

A simple pointed form representing a transition from the line to the plane, and which, therefore, unites in it the characteristics of the line and the plane, is placed upon the "most objective" BP in the directions mentioned. What results follow?

**Use**

---

[1] It would be an important task to investigate various works of art having a clear diagonal structure to determine the nature of their diagonals and their inner connection with the pictorial content of these works. I have, for instance, more than once used the diagonal structure without becoming conscious of this until later. On the basis of the formula given above, my "Composition I" (1910), for example, can be defined in the following manner: structure cb and da with forcible emphasis on cb—this is the backbone of the picture.

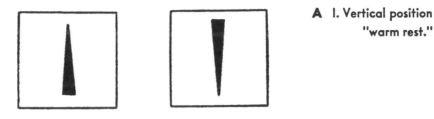

**A** I. Vertical position "warm rest."

Fig. **85**

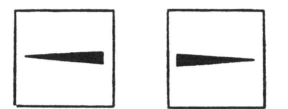

II. Horizontal position "cold rest."

Fig. **86**

**Contrasts**    Two contrasting pairs are created:

The first pair    (I) is an example of the **greatest contrast** since the form at the left is directed toward the loosest resistance and the form at the right toward the stiffest.

The second pair (II) is an example of a **mild contrast** because both forms are directed toward the milder resistances and their form tensions differ from each other but slightly.

**External Parallels**    In both cases, the forms stand in a parallel relationship to the BP which represents an **external parallelism**, since the external boundaries and not the inner tension of the BP have been taken as the basis.

An elementary combination with the inner tension requires the diagonal direction; thereby, two contrasting pairs once more result:

**130**

**B  I. Diagonal position "disharmonious."**

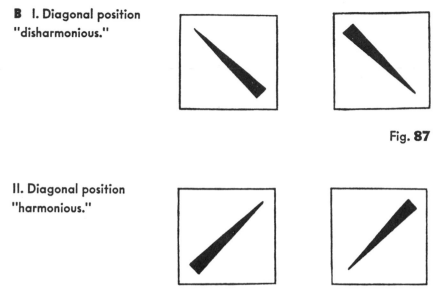

Fig. **87**

**II. Diagonal position "harmonious."**

Fig. **88**

These two contrasting pairs differ from each other in the same way as the two pairs under **A** did previously.                                    **Contrasts**

The form at the left is directed toward the loosest angle; ⎫
the form at the right is directed toward the firmest angle; ⎬   above
thereby, they represent the **greatest contrast.**                  ⎭

It is equally clear why the two lower forms constitute a ⎫   below
**mild contrast.**                                       ⎭

The relationship between the pairs under **A** and under **B** ends here.     **Inner**
The latter are examples of an **inner parallelism,** because these forms run   **Parallels**
in the same direction as the inner tensions of the BP.[1]

1 In I, the forms run in the direction of the normal tension of the square; in II, the
forms run in the direction of the harmonious diagonal.

**Composition Construction** Therefore, these four pairs present for compositional constructions eight different possibilities of basic positions, lying on the surface or hidden beneath—foundations upon which can be accumulated additional main directions of forms, which either remain centralized or deviate from the center in various directions. Yet obviously, even the first basic foundation can be off center, or the center can be altogether avoided; the number of possibilities of construction is unlimited. The inner mood of the time, of the nation and, finally, the inner strength of the personality (which is not entirely independent of the first two) determine the fundamental sound of the compositional "tendencies." This question does not belong within the scope of this specialized book, but it should be mentioned that during the last decades, first the wave of the concentric and then the wave of the eccentric alternately arose and subsided. There were various reasons for this, which are bound up partly with contemporaneous phenomena, but which are also often causally connected with much more deeply seated needs. The changes in "mood," especially in painting, proceeded on the one hand out of the wish to abandon the BP and, on the other, out of the attempt to maintain it.

**History of Art** The "modern" history of art should thoroughly investigate this subject, which passes far beyond the boundaries of purely pictorial questions and from which much that concerns the relationships to cultural history could be explained. Today, various things have come to light in this connection which a short while ago lay hidden in mysterious obscurity.

**Art and Time** To outline this briefly: three different considerations form the basis of the relationships between art history and "cultural history" (to which also belong subjects having to do with the absence of culture):

1. art submits to the time —
   a) either the time is strong and of concentrated content, and an equally strong and concentrated art follows the way of the time without effort, or
   b) the time is strong but its content decayed, and a weak art succumbs to this disintegration;
2. for various reasons, art stands in opposition to the time and gives expression to possibilities contradictory of its time;

3. art transgresses the boundaries within which the time would like to confine it, and so forecasts the content of the future.

Let it be noted briefly that the currents of our day which refer to basic structures readily conform with the above-mentioned principles. The "eccentricity" of American theatre art, to which an exact form has been given, is a clear example of the second principle. The present day reaction against "pure" art (e.g., against "easel painting") and the fundamental attacks connected therewith, belong under point b) of the first principle. Abstract art is freeing itself from the pressure of the day, wherefore it belongs under the third principle.

In this way, appearances can be explained which at first appear as something indefinable or, in other cases, as completely senseless: the exclusive use of the horizontal-vertical may easily seem inexplicable and dadaism appears to be senseless. It may seem astonishing that these two tendencies appeared almost simultaneously, and that they, nevertheless, stand in irreconcilable opposition to each other. The avoidance of all structural foundations, other than the horizontal-vertical, condemns "pure" art to death and only the "practical-useful" can escape this: the time, decayed within but externally strong, bends art to its purposes and denies its independence—point b) of the first principle. Dadaism tries to reflect this inner disintegration, whereby it naturally loses its artistic foundations and is not capable of replacing these with any of its own—point b) of the first principle.

These few examples, taken from our own time exclusively, have been given with the intention of throwing light upon the organic, often inevitable, relationships of the pure form question in art with cultural or, as the case may be, non-cultural forms.[1] This has the purpose, furthermore, of pointing

**The Question of Form and Culture**

---

[1] This "today" is made up of two basically different parts—blind alley and threshold—with a great preponderance of the first. The predominance of the blind alley theme excludes the use of the term "culture"—the time is altogether without culture, although a few seeds of a future culture can be discovered here and there—threshold theme. This thematic disharmony is the "sign" of "today" which continually forces itself upon our attention.

out that attempts to explain art on geographic, economic, political or other purely "positive" grounds can never be conclusive, and that one-sidedness cannot be avoided if these methods are used. Only the connection between questions of form in the two above-mentioned fields, on the basis of their spiritual content, can point out the exact line of direction. "Positive" conditions play, hereby, a subordinate role—fundamentally, they themselves are not determining factors but, rather, a means to the end.

Not everything is visible and tangible, or—to be more explicit—under the visible and comprehensible lies the invisible and incomprehensible. Today we stand on the threshold of a time in which one—but only one—step leading into the depths is gradually coming more and more to the fore. In any case, we have an inkling of the direction in which our foot must seek the further step. And that is the salvation.

In spite of all the apparently insurmountable contradictions, the present-day human being is, indeed, no longer satisfied with the external alone. His vision is becoming sharper, his ear keener, and his desire to see and to hear the inner in the outer ever increases. Only that way are we able to feel the inner pulsation of even as taciturn and as modest a thing as the BP.

**Relative Sound**

This pulsation of the BP, as was shown, is transformed into double and multiple sounds when the simplest element is placed upon the BP.

A free curved line, consisting of two bends toward one side and three bends toward the other, has an obstinate "look" because of its broad upper part, and ends in a bend directed downwards and becomes ever weaker. This line expands as it moves upward, the expression of curvature becomes

**Left Right**

**134**

more and more forceful until the "obstinacy" attains its maximum. What happens to this obstinacy when it is directed first to the left and then to the right?

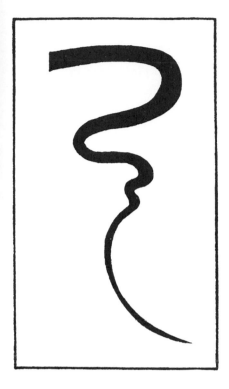 

Fig. **89**
Obstinacy with forebearance.
The bends are loose.
Resistance from the left, weak.
At the right, compressed layer.

Fig. **90**
Obstinacy in stiff tension.
The bends harder.
Resistance from the right strongly
restraining. At the left, loose "air."

Turning this example upside-down is especially fitted to the investigation of the effects of "above" and "below," and this is something the reader can do for himself. The "content" of the line changes so radically that the line is no longer recognizable: the obstinacy disappears completely and is replaced by a laborious tension. The concentration is no longer present and

**Above
Below**

**135**

everything is in the process of growing. When the line is turned toward the left, this growing is more pronounced; toward the right—the laborious.[1]

**Plane upon Plane**

I will now pass beyond the limits of my task and place upon the BP not a line, but a plane, which is but the inner significance of the tension of the BP. (See above.)

The standard distorted square upon the BP.

Fig. **91**
Inner parallel
of lyrical sound.
Concurrence with the inner
"disharmonious" tension.

Fig. **92**
Inner parallel
of dramatic sound.
Contrast to the inner
"harmonious" tension.

**Relation to the Border**

The **distance** of the form from the borders plays a special and very important role in the relationship of the form with the borders of the BP. Let a simple straight line of uniform length be placed upon the BP in two different ways (Fig. **93** and **94**).

In the first case, it lies free. In approaching the border it takes on a pronounced, increased tension toward the upper right and hereby the tension of the lower end becomes weakened (Fig. **93**).

---

[1] In such experiments it is advisable to rely upon the first impression because the power of perception tires rapidly and lets the imagination run rife.

In the second case, it strikes the edge and thereby immediately loses its tension upwards. As a result, the downward tension increases and it acquires a sickly, almost despairing expression (Fig. **94**).[1]

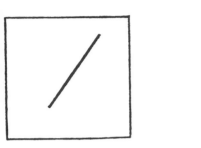

Fig. **93**

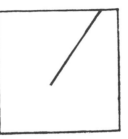

Fig. **94**

In other words: on approaching the boundary of the BP, a form increases in tension until, at the moment of contact with the boundary, the tension suddenly ceases. Furthermore: the farther a form lies from the edge of the BP, the weaker becomes the attraction of the form to the edge. Or: forms lying near the border of the BP augment the "dramatic" sound of the construction, whereas those forms lying away from the border, which gather more about the center, lend a "lyrical" sound to the construction. These are, naturally, schematic rules which, by other means, can be brought to their full validity or can be reduced to a barely audible sound. Nevertheless, they are always effective to a greater or lesser extent, a fact which emphasizes their theoretic value.

A few examples will serve to explain clearly the typical cases of this rule:     **The Lyric**
**The Dramatic**

---

[1] This increased tension and the adherence of the line to the upper edge make it appear longer in case 2 than in case 1.

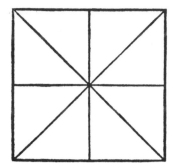

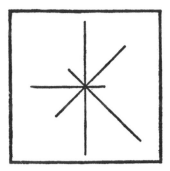

Fig. **95**
Silent lyric
of the four elementary lines—
expression of rigidity.

Fig. **96**
Dramatization
of the same elements—
complex pulsating expression.

Use of the eccentric:

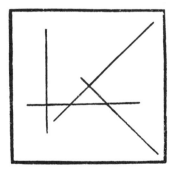

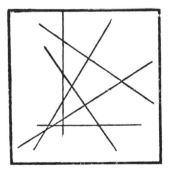

Fig. **97**
Diagonals centered.
Horizontal-vertical acentric.
Diagonals in the greatest tension.
Balanced tensions of the
horizontal and vertical.

Fig. **98**
Everything acentric.
Diagonals strengthened
through their repetition.
Restraint of the dramatic sound
at the point of contact above.

The acentric structure here serves the purpose of increasing the dramatic sound.

If, for instance, simple curved lines were to be used in the examples given above instead of straight lines, the sum of the sounds would become three times as great. Every simple curved line, as was said in the section on Line, consists of two tensions, which produce a third. Furthermore, if simple curved lines are replaced by wave-like lines, every bend would represent a simple curved line with its three tensions, and the sum of the tensions would accordingly become greater and greater. The relation of each bend to the edges of the BP would hereby complicate this sum by louder or fainter sounds.[1]

**Increasing the Number of Sounds**

The relationship of planes to the BP is a theme in itself. The rules and regulations given here retain, nevertheless, their full validity and point the way in which this special theme should be treated.

**Regularity**

Thus far, only the square BP has been considered. The remaining right-angled forms are products of the predominance or preponderance of the pair of horizontal boundaries or of the vertical. In the first case, cold rest gets the upper hand; in the second, warm rest; this obviously determines from the start the basic sound of the BP. Striving upward and stretching outward are antipodes. The objectivity of the square disappears and is replaced by a one-sided tension of the whole BP which—more or less audible—influences all the elements on the BP.

**Further BP Forms**

We should not fail to mention the fact that both of these types are of a considerably more complex nature than the square. In the horizontal format, for example, the upper edge is longer than the side edges and so creates more possibilities in the direction of "freedom" for the elements, but these are soon suppressed again by the shortness of the sides. The contrary is true in the vertical format. In other words, the boundaries in these cases are much more dependent upon each other than they are in the square. It gives the impression that the surroundings of the BP participate and exert a pressure from the outside. Thus, in the vertical format, full play upward is facilitated because the pressure of the surroundings

---

[1] The compositional diagrams included here illustrate such cases. (See appendix.)

from without is almost altogether lacking in this direction and is chiefly concentrated at the sides.

Further variations of the BP are produced through the use of obtuse and acute angles in the most diverse combinations. New possibilities develop out of the opportunity to shape the BP in such a way that it confronts the elements with the angle at the upper right, in either a reinforcing or restraining manner (Fig. **99**).

Fig. **99**
Reinforcing
and restraining (dotted) BP.

There can also be many-angled basic planes which, nevertheless, in the final analysis must be classified under **one** basic form and, therefore, represent more complicated cases of the given basic form, which we need not consider any further here (Fig. **100**).

Fig. **100**
Complex many-angled BP.

The angles can be present in ever increasing numbers and can thereby become more and more obtuse—until, finally, they completely disappear and the plane becomes a circle.

This is a very simple and, at the same time, a very complex case, concerning which I intend sometime to speak at length. It suffices here to remark only that the simplicity as well as the complexity result from the absence of angles. The circle is simple because the pressure of its boundaries by comparison with those of right-angled forms is equalized—the differences are not so great. It is complex because the upper part overflows imperceptably to the left and right, and the left and right flow downwards. There are only four points which retain the decided sound of the four sides which, furthermore, is quite clear from the standpoint of feeling.

These points are 1, 2, 3, 4. The contrasts are the same as in the right-angled forms: 1—4 and 2—3 (Fig. **101**).

Fig. **101**          **141**

From the top toward the left, the quadrant 1—2 represents a gradually increasing restriction of the maximum "freedom," and in the course of the quadrant 2—4, this changes into hardness, etc., until the progress around the circle is completed. The facts established in describing the tensions in the square hold true for the tensions of the four quadrants. Thus, basically, the circle has the same inner tension concealed within it as was discovered in the square.

The three basic planes—triangle, square, circle—are, of course, products of the systematically moving point. When two diagonals, whose ends are connected by horizontals and verticals, are passed through the center of the circle, the result is the basis of Arabic and Roman numerals, according to A. S. Puschkin (Fig. **102**):

Fig. **102**
Triangle and square in circle,
as basic source of numerals:
Arabic and Roman.
(A. S. Puschkin, Works,
Petersburg, Verlag Annenkoff,
1855, Vol. V, p. 16.)

$$A D = 1$$
$$A B D C = 2$$
$$A B E C D = 3$$
$$A B D + A E = 4$$
etc.

Thus meet here:

1. the roots of two numerical systems, and
2. the roots of the forms of art.

If this deep-going relationship actually exists, we have a certain confirmation of our surmise that phenomena which seem to be fundamentally different on the surface and completely separate from each other derive from one single root. Today, especially, the necessity of finding this common root appears inevitable to us. Such necessities do not arise without an inner motivation, but many determined attempts are required in order finally to satisfy them. These necessities are of an intuitive nature. The road to fulfillment is also chosen intuitively. The rest is a harmonious combination of intuition and calculation—in the long run neither the one nor the other alone suffices.

One proceeds by way of the uniformly compressed circle, of which the oval is a result, to free basic planes. These are, to be sure, without angles but, just as is possible in the case of angular forms, they also pass beyond the limits of geometric forms. Here, as well, the fundamental principles will remain unchanged and will be recognizable behind the most complex forms.

**Oval Form**
**Free Forms**

Everything which in very general terms has been said here about the BP must be looked upon as a fundamental schematization, as an approach to inner tensions which exercise their effect in a plane-like manner, so to speak.

The BP is material: it is created in a purely material way and is dependent upon the nature of this creation. As already has been mentioned, the most diverse textural possibilities are available for this creation: the smooth, rough, grainy, prickly, glossy, dull, and finally the plastic surface which

**Texture**

1. isolates, and
2. in combination with the elements gives especial emphasis to the inner effects of the BP.

**143**

Of course, the characteristics of the surface depend entirely upon the characteristics of the materials (canvas and its nature, stucco and the manner of its treatment, paper, stone, glass, etc.), and the tools associated with the materials, their use and handling. Texture, which we cannot discuss here at length, is—like every other means—a precise, but elastic, pliable potentiality for proceeding schematically in two directions:

1. the texture takes a road parallel to that of the elements and thereby supports them in an external manner primarily, or it is used
2. in accordance with the principle of contrast; that is, it stands in external opposition to the elements and supports them inwardly.

The possibilities of variation lie in-between.

Aside from the materials and the tools for the producing of a material BP, the same consideration must, of course, be given the materials and the tools for the production of the material form of the elements. This belongs in a detailed study of the theory of composition.

It is important here to point the way to possibilities of this kind, since all of the suggested modes of creation, with their inner consequences, can serve not only in the building up of the material plane, but in the optical destruction of this plane as well.

**Demateri- alized Plane**

The elements lying firmly (materially) on a solid, more or less hard and, to the eye, tangible BP and, in contrast, the elements "floating" without material weight in an indefinable (immaterial) space are of fundamentally different appearance, and stand in antithesis to each other. The general-materialistic point of view which, naturally, also extended to all expressions of art, brought about the natural, organic result of exceptional esteem for the material plane, together with all of its ramifications. To this one-sidedness, art owes its sound, indispensable interest in handicraft, in technical knowledge and especially in a thorough consideration of the "material" itself. It is especially interesting that, as has been said, this detailed knowledge is unquestionably necessary—not only for the purpose of the material production of the BP, but also for the purpose of its dematerialization in

**144**

combination with the elements—the road from the external to the inner.

It must nevertheless be strongly emphasized that the "floating sensations" depend not alone upon the above-mentioned conditions, but also upon the inner attitude of the observer whose eye can be capable of seeing in one or the other, or in both ways: if the inadequately developed eye (which is organically connected with the spirit) cannot experience deeply, it will not be able to emancipate itself from the material plane in order to perceive the indefinable space. The properly trained eye must have the ability partly to see the plane, as such, necessary to the work of art and partly to disregard it when it takes on spatial form. A simple complex of lines can finally be treated in two ways—either it has become one with the BP or it lies free in space. The point clawing its way into the plane is also able to free itself from the plane and to "float" in space.[1]

Just as the inner tensions of the BP described above continue to exist in the complex BP forms, these tensions are also transferred from the dematerialized plane to the indefinable space. The law does not lose its effect. If the point of departure is correct and the direction taken is well chosen, the goal cannot be missed.

And the goal of a theoretic investigation is
1. to find the living,
2. to make its pulsation perceptible, and
3. to determine wherein the living conforms to law.

---

[1] It is clear that the transformation of the material plane and the general character of the elements combined with it are certain to have very important consequences in many respects. One of the most important of these is the change in the feeling for time: space is identical with depth; also, with the elements receding into depth. It is not without reason that I have called the space resulting from dematerialization "indefinable"—its depth is, after all, illusory and, therefore, not exactly measurable. Thus, time cannot in these cases be expressed in figures, and so it cooperates only relatively. On the other hand, the illusory depth is an actual one from the pictorial point of view and consequently a certain, even though immeasurable, time is required to follow the form elements receding into depth. Therefore: the transformation of the material BP into indefinable space offers the opportunity of increasing the span of time.

Living facts—as isolated phenomena and in their interrelationships—can be gathered in such a manner. It is the task of philosophy to draw conclusions from this material, and it is a work of synthesis of the highest order.

This work leads to such inner revelations as can be given to each epoch.

# APPENDIX

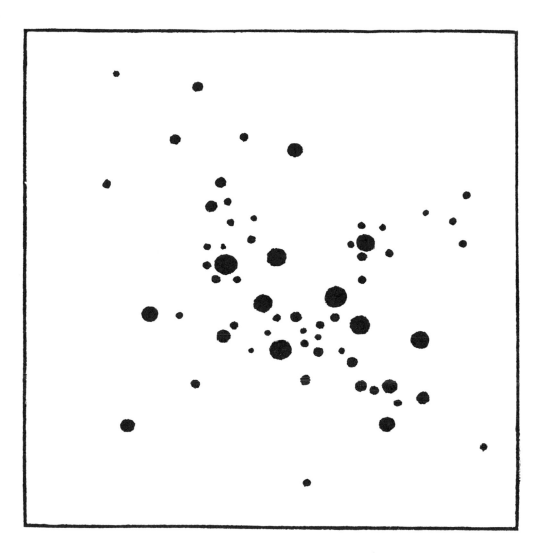

**Diagram 1**
Point
**Cool tension toward the center**

**Diagram 2**
Point
**Dissolution in progress (suggested diagonal d-a)**

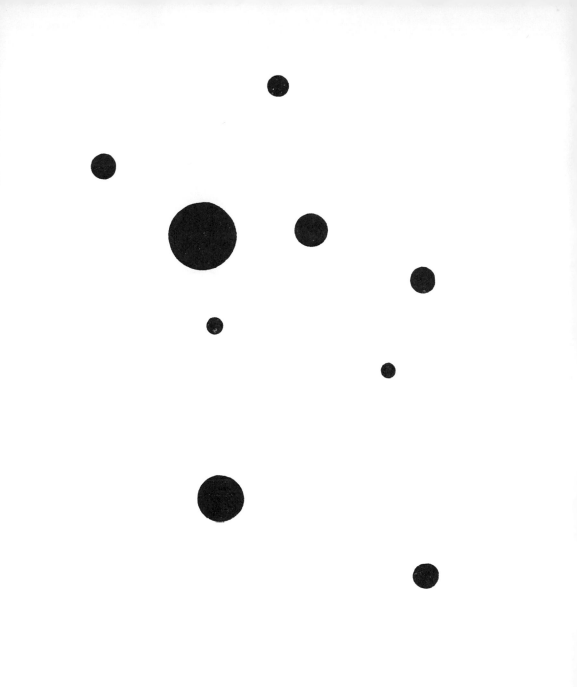

**Diagram 3**
Point
**9 points in ascent (emphasis upon the diagonal d-a through weight)**

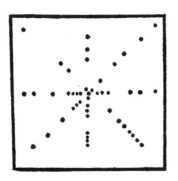 

**Diagram 4**
Point
**Horizontal-vertical-diagonal point pattern for a free line construction**

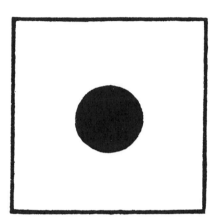 

**Diagram 5**
Point
**The black and white points as elementary colour values**

**Diagram 6**
Line
**The same in linear form**

**Diagram 7**
Line
**With a point on the edge of the plane**

**Diagram 8**
Line
**Emphasized weights in black and white**

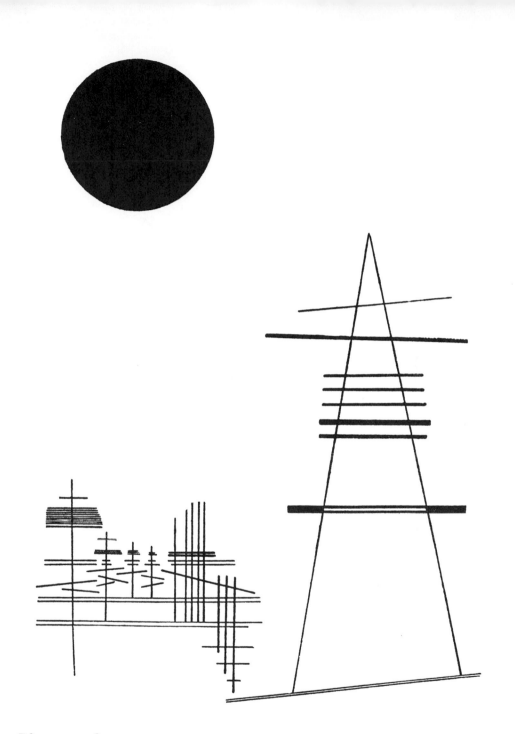

**Diagram 9**
Line
**The thin lines hold their own in the presence of the heavy point**

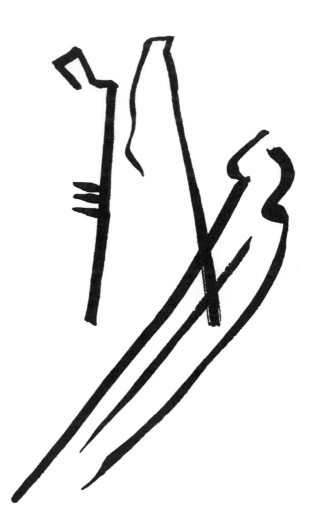

**Diagram 10**
Line
**Graphic structure of a part of "Composition 4" (1911)**

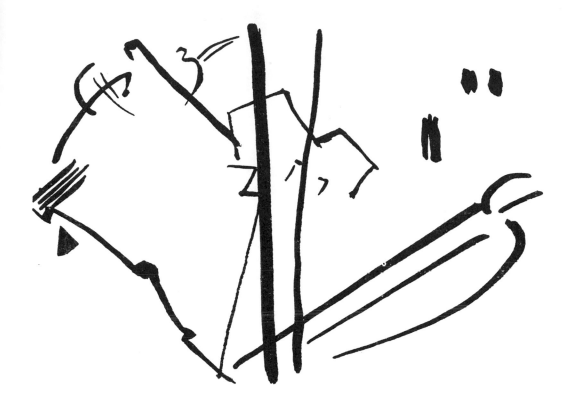

**Diagram 11**
Line
**Linear structure of "Composition 4"—vertical-diagonal ascent**

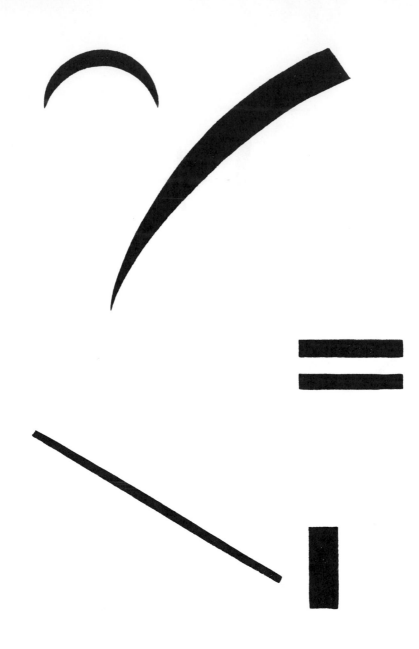

**Diagram 12**
Line
**Eccentric structure in which the eccentricity is emphasized by the developing plane**

**Diagram 13**
Line
**Two curved lines to one straight line**

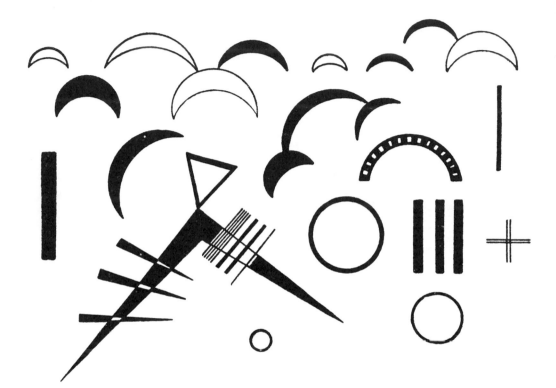

**Diagram 14**
Line
**The horizontal format favors the total tension of individual forms in slight tension**

**Diagram 15**

Line

**Free curve to the point—accompanying sound of geometric curves**

**Diagram 16**
Line
**Free wave-like line with accent—horizontal position**

**Diagram 17**
Line
**The same wave-like line accompanied by geometric lines**

**Diagram 18**
Line
**Simple and unified complex of several free lines**

**Diagram 19**
Line
**The same complex complicated by free spirals**

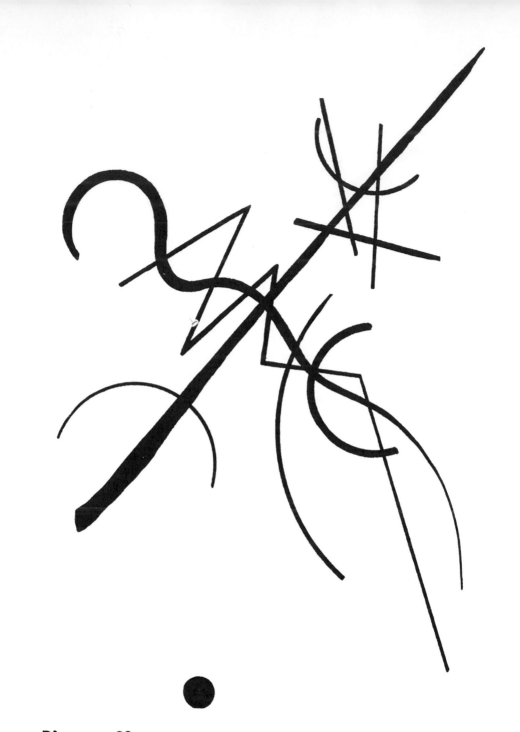

**Diagram 20**
Line
**Diagonal tensions and counter-tensions with a point which brings an external construction to inner pulsation**

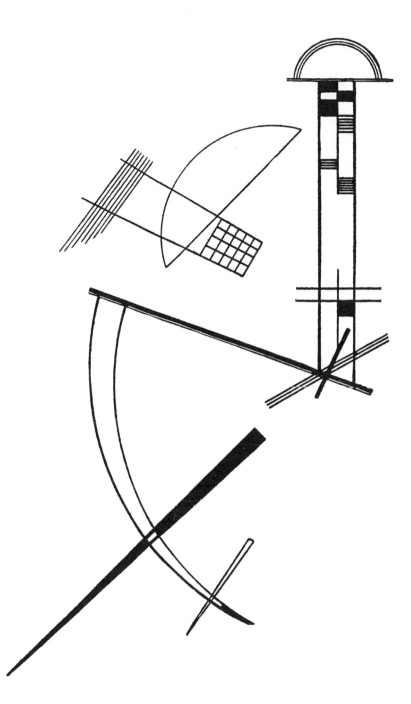

**Diagram 21**

Line

**Double sound—cold tension of the straight lines, warm tension of the curved lines, the rigid to the loose, the yielding to the compact**

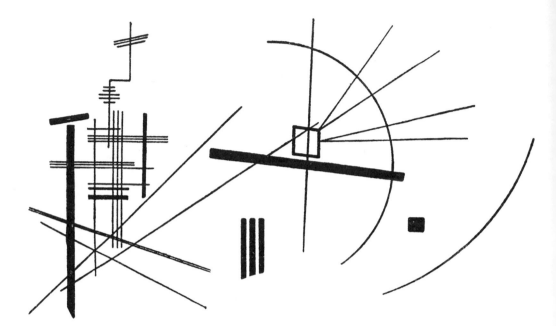

**Diagram 22**
Line
**Colour vibration attained in essence through a minimum of colour (black)**

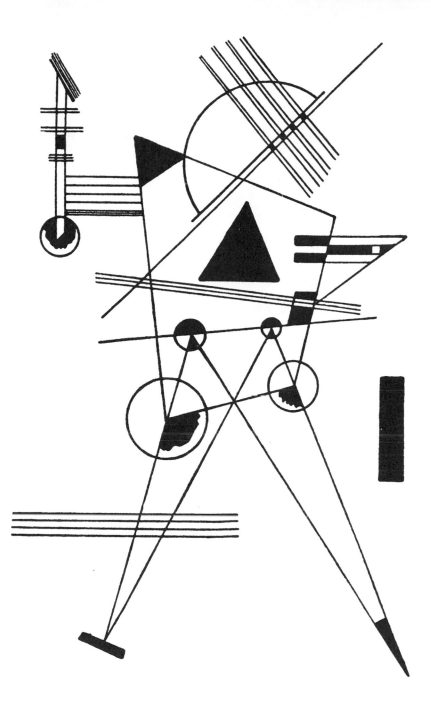

**Diagram 23**
Line
**Inner relation of a complex of straight lines to a curve (left-right) from the picture "Black Triangle" (1925)**

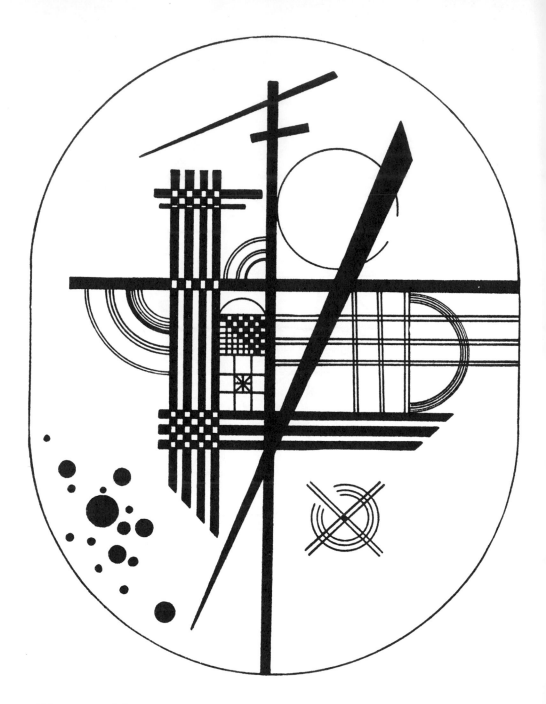

**Diagram 24**
Line
**Horizontal-vertical structure with contrasting diagonal and point tensions—scheme for picture "Intimate Communication" (1925)**

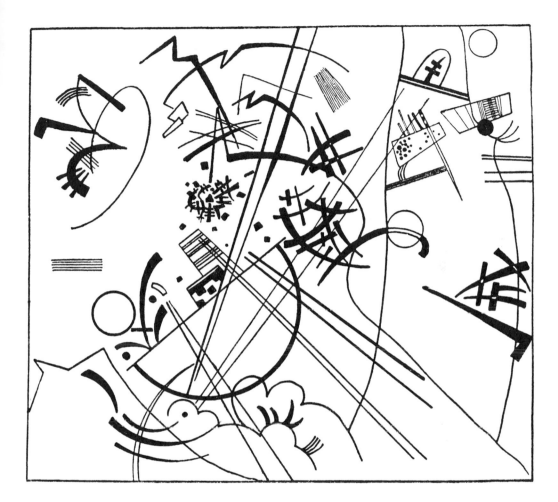

**Diagram 25**
Line
**Linear structure of the picture "Little Dream in Red" (1925)
(cover)**

# INDEX